"*Manage Money Like a Boss* will profoundly shift the way you think about money and entrepreneurship. Christine lays out a simple, yet profound strategy for creative entrepreneurs to succeed financially in business, and as she writes, 'change the world for the better.'"

— Barbara (Stanny) Huson, bestselling author of
Sacred Success: A Course in Financial Miracles

"I love this book! In *Manage Money Like a Boss*, Christine Luken gives a practical approach to handling money as an entrepreneur. Something that most want to bury their heads in the sand about. I love how easy the book was to read and the action steps and exercises at the end of each chapter. The author literally covers it all, from pricing and owning you worth to cash flow, managing money, paying yourself, investing, and more! I wish I had this book 5 years ago when I started my business."

— Jenn Scalia, Visibility and Mindset Strategist,
bestselling author of *Your First Six Figures: Eight Keys to Unlock Freedom, Flow, and Financial Success with Your Online Business*

"In *Manage Money Like a Boss*, Christine has not only dissolved the anxiety and frustration surrounding finances for creative entrepreneurs, she's given us an outlook and tools that are uniquely empowering because of the way we're wired. She's transformed our sensitivities into magnificent assets. A necessary work and one we've been waiting for."

— Ashley Peacock, Music Producer & Owner of Soul Foundry

"Christine's book *Manage Money Like a Boss: A Financial Guide for Creative Entrepreneurs* is a book that should be mandatory for all entrepreneurs. As business owners, we are often focused on marketing and strategies for making money, but then completely forget about how to actually manage that money. I love the fact that the book gives an incredible money mindset foundation before going into all of the great advice for being financially smart. I'm making this book mandatory reading for every single one of my clients!"

— Fabi Paolini, Brand Strategy Coach

"*Manage Money Like a Boss* is a must-read for all entrepreneurs, whether you're in a creative business or not! This no-nonsense guide to managing your business finances is packed full of wise advice, relatable stories, and actionable tips. You'll certainly get a big return on your investment in this book if you apply what Christine suggests."

— Mark Dolfini, Landlord Coach & Author of
*The Time-Wealthy Investor: Your Real Estate Roadmap to
Owning More, Working Less, and Creating the Life You Want*

MANAGE MONEY
LIKE A BOSS

A Financial Guide for Creative Entrepreneurs

MANAGE MONEY
LIKE A BOSS

A Financial Guide for Creative Entrepreneurs

CHRISTINE LUKEN
The Financial Lifeguard

MANAGE MONEY LIKE A BOSS
A Financial Guide for Creative Entrepreneurs

Printed in the United States of America
ISBN: 978-0-9985912-1-6

All dictionary entries and references, unless otherwise noted, are taken from Dictionary.com, accessed August 8, 2018.

Cover art and manuscript layout by Heather Rae Hutzel at HeatherRaeHutzel.com/AuthorResources

Back cover author photo credit: Amy Oliver
www.photographsbyamyoliver.com

Learn more information at:
www.ChristineLuken.com

DEDICATION

To Carol Mitchell, My Mom:

Thank you for encouraging me to pursue my creative writing plus my business goals and for always believing in me no matter what. I couldn't have picked a better woman to be my mother and role model.

Acknowledgments

I am blessed to be surrounded with a tribe of amazing, creative, supportive, and kick-ass people in my life and business. Here are a few of the many people who deserve a big Thank You for encouraging me during the process of writing this book.

God Almighty, the Great Creator, and the source of all things good in my life.

Nick, my husband, thank you for unconditionally loving me and supporting me on this sometimes-crazy adventure of entrepreneurship.

My Dad (Tom Luzak), thank you for modeling the grit and bravery of business ownership, and teaching me everything you know.

Nicholle Bays, my forever bestie, thank you for always being just a phone call away to cheer me up or celebrate victories.

Heather Hutzel, my co-conspirator and sounding board, thank you once again for an amazing cover design. You understand the angst and joy of writing and publishing a book, so thanks for occupying the passenger seat during this crazy ride with me.

Ashley Peacock, my amazing iron-sharpens-iron friend. Thanks for regularly reminding me that I'm good enough, I'm smart enough, and gosh darn it, people like me.

Dan Bisig, man, what can I say? You're an awesome friend, a wise counselor, and one of my biggest cheerleaders. You have my unending gratitude.

Jill Morenz, my creative critiquer, this book is better because of you.

Blanche Gaynor, my editor, thank you for your eagle-eyed appraisal of this manuscript.

To my inner circle, for your friendship, and constant support: Jim Luzak, Nanette Polito, Sandi and Dan Hammons, Glenn and Shelley Warner.

My "Dream Team," thank you for spreading the word to creative entrepreneurs far and wide about this book. You are greatly appreciated.

To many business coaches and creatives who I interviewed for this book. Thank you for your contribution!

Finally, a big THANK YOU to all of you who supported me in some form or fashion during the writing of this book. There are far too many of you to mention by name, but you know who you are. Please know I am eternally grateful for your friendship and support!

TABLE OF CONTENTS

INTRODUCTION

All your life, you've been fed lies.

You've been fed the lie that money is evil. You've been fed the lie that you're not good with numbers. You've been fed the lie that selling your art will make you a sellout.

Because you've swallowed these lies, they block you from living your life to the fullest. You can't support the people you so desperately want to help. You can't contribute to the causes that are close to your heart.

Please stop eating these lies you're being fed. Instead, it's time to spit them out. It's time to declare the truth:

"Money is NOT evil. Money is a tool. And in my hand, this tool is a force for good. I choose to use money to positively impact my own life and the world around me."

I have a confession to make: I almost didn't write this book for you.

When I began writing *Manage Money Like a Boss*, my intended audience was anyone with a small business. But then I noticed something interesting. I noticed many of the creatives I know have this strained push-pull relationship with money and success. They *want* to make more income in their creative businesses, yet at the same time they resent needing money to sustain themselves.

I noticed something else. I noticed that many financial and business gurus marginalize the artistic community. Accountants talk over creatives' heads, using jargon to confuse or perhaps impress them. Or, worse, "bring it down to their level," and

1

address creatives like children who couldn't possibly understand the numbers.

That's why I chose to write this book specifically for *you*, the creative entrepreneur. I feel compelled to disprove these lies. Money is not evil. Money is not hard to understand. Money is a tool. And you can use this tool in your creative business to design a fulfilling life for yourself while positively impacting the world around you.

So, I wrote this book for you because you deserve a guide that shows you the truth about how to manage your money and business in a way that honors your creativity rather than shoving it to the side.

As you read the book, you'll see each chapter ends with a *Creative Money Exploration*. These are designed specifically to apply the lessons you'll learn to your business, so I encourage you to fully engage in them. You'll want to download the free *Manage Money Like a Boss Workbook* at ManageMoneyLikeABoss.com. It contains all of the *Creative Money Explorations* and room for your answers and reflections.

Manage Money Like a Boss will empower you to discover and embrace the truth about money. Because you and money *can* change the world through your creative business. This book will give you both the confidence and competence to manage your money like a boss.

Note: Many names and identifying details have been changed in the stories and examples throughout this book to protect identities and maintain client confidentiality.

Disclaimer: I am not a CPA, attorney, or financial planner. Please consult with the appropriate financial or legal professional before making major changes to your business operations, organization, or investment strategies. Christine Luken and 7 Pillars, LLC cannot be held responsible for any outcomes, either positive or negative, as a result of the suggestions in this book.

PART ONE

Money: Developing a Boss Mindset

CHAPTER 1

Struggle with Math, Struggle with Money?

While in art school, Drew Kidd, lifelong creative entrepreneur, distinctly remembers the lack of financial and business education in the curriculum. Although Drew didn't struggle with math, many of his fellow students did. The professor told his class that 95% of graduating art majors would not be in artistic careers after 5 years. Nor did Drew and his peers receive any guidance about managing money or navigating the business world (certainly not entrepreneurship) in college. In fact, when Drew asked one of his teachers about making money with his art out in the marketplace, the teacher said, "We already have our curriculum for the semester. We don't have time to talk about that." It's unlikely his professor could give good advice on the subject anyway. Unsurprisingly, many creative entrepreneurs don't feel they have the skills and knowledge to master their money, especially because they weren't good at math in school. Maybe you can relate.

Thirty percent (30%) of Americans say they would rather clean the bathroom than solve a math problem. Are you one of them? If so, you might think money management is difficult and confusing because it's all about math. I have a revelation for you: money doesn't equal math. You don't have to be a former high school mathlete to win with money in your business and

personal life. Math is just a small component of personal finance, and there are plenty of tools (many accessible right from your smart phone) that will actually do the math for you.

Creatives, are you aware the principles of math are intertwined with art and music? Fractions are used in music to indicate lengths of notes. Artists and designers are familiar with the "Golden Ratio" and how it creates pleasing proportions. Plus, there is much more to money than just the numbers.

Money is emotional and that's not necessarily a bad thing. Math itself is purely logical; it is governed by rules and formulas. In math, there is *always* a right answer. But personal finance is *not* so cut-and-dry. When people ask me specific questions about money management, my first answer is almost always, "It depends." I usually need more information about the person's individual situation to give a solid answer that will truly guide them in the right direction.

Creatives are in tune with emotion and can use this to their advantage with money. By paying attention to the emotions we feel when we interact with money—whether spending, saving, borrowing, or investing—we can uncover our underlying emotional triggers. We can then infuse positive emotions to our goals and use negative emotions to prevent ourselves from engaging in destructive money behaviors. Throughout this book, I will give you "creative money explorations" that will show you how to harness the power of your emotions to win with your business and personal finances.

Money is currency and currency is energy. Creatives are more in tune with energy and flow than people who are logical thinkers. Money has an energy to it, and we can control whether this energy is positive or negative. Unfortunately, we may have received negative messages about money and wealth early in life that are causing us to have a dysfunctional relationship with our finances. The good news is we can reprogram these negative thoughts into positive ones. Your mindset around money will either make you or break you in your business, so it's vitally important to get this right.

Our thoughts and words are creative forces, and they give birth to our emotions. The job of your non-conscious brain is to

keep you safe and in agreement with your conscious mind. It prevents you from seeing things that conflict with your beliefs and draws things to you that agree with your thoughts and words. When we say negative things about our finances, we are creating more of that in our lives. Think of your thoughts and words like tubes of paint. If the colors are dark and depressing, no matter the technique of your brush strokes, you will end up with a dark and depressing painting. It's time to exchange those dark thoughts for lighter, brighter colors if you want to create a joyful masterpiece with your money and your business.

When it comes to money, *think about what you've been thinking about.* What are you saying to yourself—both out loud and in your head—when it comes to money? Are you saying things like this:

- "That's too expensive."
- "I'll never pay off these student loans."
- "Even if I work myself half to death, I will never have enough money to pay the bills."
- "I never seem to have any money left over to invest in my business."

Here is a startling fact: the conscious part of our brain only controls 2-4% of our actions! Our non-conscious brain controls the other 96-98% of our behavior. You might find this discouraging. "How am I supposed to change my behavior if the conscious part of my brain controls less than 5% of my actions?" you may ask. Here's the silver lining: you can use your conscious mind to *choose* the thoughts you want to believe and systematically impress them through repetition onto your non-conscious mind.

What's the answer to ridding our brains of negative money thoughts? We *can* control what we think. The first step is to become aware of these thoughts by capturing and recording them. We need to reprogram our non-conscious brains by replacing the negative with positive, productive money

thoughts. Look at your list of negative money thoughts and turn them into positives. For example:

- "I'm the kind of person who can give, spend, and save money freely and joyfully."
- "It's normal for me to make large payments on my student loans, and they'll be gone in no time."
- "I enjoy my work, and it provides me with adequate times of rest and more than enough money to pay the bills."
- "My business is flourishing, and I have the funds to reinvest in its future growth."

If you can grasp the power and importance of your thoughts and words when it comes to your money and your business, then positive change is inevitable. Positive thoughts will lead to positive action, which will lead to positive habits. It does take time for these changes to manifest, just as it takes time for an acorn to grow into an oak tree. Repetition is the key to impressing these positive thoughts on your non-conscious mind, which will crowd out and replace the negative thoughts.

When you first start saying your positive money affirmations, you'll feel like a fraud and a liar. That's okay! Keep saying them out loud daily until your feelings catch up with your words.

CREATIVE MONEY EXPLORATION

Using your phone or an index card, capture the negative money thoughts and words that pop into your head and out of your mouth over the next three days. Download the *Creative Money Exploration Workbook* here:

<div align="center">www.ManageMoneyLikeABoss.com</div>

Using the workbook, write down 10 negative things you think or say about money. Rewrite them as positives which will become your daily affirmations. Commit to saying them out loud every day, or if you have a daily journaling practice, write them

out. Repetition rewires your brain to think these positive money thoughts as your new normal.

CHAPTER 2

Explore Your Money Narratives

Jason grew up as the oldest child of a single mother. His father abandoned his family when he was just 7 years old. At a young age, Jason felt responsible to help care for his mother and two younger sisters. He understood that money was scarce, and he witnessed his mother accepting help from family, church members, and even strangers to feed and clothe them. Fast forward 25 years, and Jason is an extremely successful business owner. He has purchased a home for his mother and pays many of her bills, with money left over. However, Jason is still fearful of the future and experiences guilt over spending money. His net worth is ten times that of most of his peers, but he is still operating out of his old narrative of "there's never enough money to go around." Jason unconsciously clings to and operates from his past money story, even though it no longer applies to his current financial reality.

Our negative money thoughts and words have a source. Often our parents, grandparents, teachers, or other authority figures speak negatively about money to us in our childhood, and we internalize these messages as the truth. How many of us have heard, "Money doesn't grow on trees!" Or "Do you think I'm made of money?" Hearing things like this, especially at a young age, causes us to feel guilt or shame around wanting more money. This leads to adults who say they *want* to make more

money in their business yet unconsciously repel money because of the underlying feelings of shame and guilt.

"Breaking people from a poverty mindset is hard when it was in the air they breathed growing up. They don't believe their dreams are attainable," says Allen Woods, one of the founders of MORTAR, a start-up incubator that aims to cure poverty with entrepreneurship. "It takes a lot of inner work to move from a mindset of lack to one of prosperity, from just surviving to thriving. Who you surround yourself with is vitally important, especially for the self-employed. Sometimes those closest to us can undermine our confidence, maybe out of jealousy."

All of us have money narratives from our past which color our present financial behaviors. These money stories usually contain some grain of truth and may have served a useful purpose for us in the past. However, when our money narratives contain some falsehood or aren't applicable to our current situation, they can harm our financial health. These half-truths about money are typically passed down to us from our parents, pastors, teachers, or grandparents. Take some time to reflect upon how your parents and other authority figures talked about money. Are you internalizing their money narratives as your own?

When people find themselves repeating the same mistakes around money, there are usually unresolved emotional issues stemming from a past event or relationship. We first need to identify these unproductive money narratives and revisit these sometimes-painful memories before we can fully embrace a new way of handling our money. When we uncover these narratives and examine them objectively, we can determine whether they are helping or hindering our journey to financial health. We can then proactively rewrite our money stories to have happy endings.

Here are some common money narratives:

- "If I had more money, life would be so much better."
- "Money is the root of all evil."
- "I don't deserve more money."

- "I deserve to spend all the money I want."
- "Money isn't important to me."
- "Financial success will make me important."
- "Nice people don't talk about money."
- "If I'm a good person, God/the Universe will take care of me."

Chris Salem, author and host of the *Sustainable Success* radio show, says, "If you have faulty money beliefs, you must identify the root. This is a process, not a quick fix. You will need to resolve the root of your mindset issues before you can achieve wealth in your business."

Left unexamined, these money stories and emotionally charged events of our past can continue to haunt us and harm us, forming impassable road blocks on our journey to financial health. For some, counseling, therapy, or energy work is beneficial and necessary to heal and release these emotional wounds.

CREATIVE MONEY EXPLORATION

Write down a memory from your childhood that still has a lasting effect on how you handle money now. Is this narrative serving you or holding you back?

CHAPTER 3

Money is Not Evil

One of the most damaging money narratives we can cling to is the fallacy of "money is evil." Unfortunately, we may hear messages from family members or in our churches such as, "Money is the root of all evil," and "Blessed are the poor." Too many people cling to this narrative of "money is evil."

Money is neither good nor evil, just as a pen, or any other inanimate object, is neither good nor evil. Money is simply an extension of the person using it. You can take $10,000 and donate it to a homeless shelter. You can also take $10,000 and buy enough explosives to blow up the homeless shelter. The money doesn't choose how it's being spent in the same way a pen doesn't decide what it's going to write on the piece of paper in front of it. It all depends on whose hand it is in. The same pen could be used to write a sweet love letter one day and vicious hate mail the next. We don't blame the pen for what's written; rather, we ascribe responsibility to the writer. But how many times have you heard someone say, "money is evil"?

My ex-fiancé, Jeff, and his family were plagued by the narrative that having money is immoral and rich people are evil and greedy. I remember when Jeff received a promotion at a sales job which meant a company truck. We visited his family for a holiday gathering, driving the truck to go and see them. Rather than congratulate him on his career success, one of his

uncles said with a chuckle, "Look at you moving up in the world and getting a company car. Pretty soon you're going to be too good to come and see us here in the trailer park." Even said in a teasing tone, his uncle implied Jeff shouldn't aspire to be more prosperous than the rest of his family. If he were to continue his success, money might corrupt him and he would turn his back on his family. Unsurprisingly, Jeff self-sabotaged. He got a DUI, wrecking the truck and losing his job in the process.

Religion is guilty of transferring this belief that secular success and spiritual prosperity are mutually exclusive. Growing up in the church, I was taught that "money is the root of all evil," "blessed are the poor," and something about rich men having to squish a camel through the eye of a needle if they wanted to go to heaven. I figured if you were rich, your prospects of heaven were pretty bleak, so you better at least enjoy your life on earth. Unfortunately, some of these bible verses have been misunderstood and taken out of context. If like me, you've been ingrained with this line of thinking, I highly recommend you read or listen to DeVon Franklin's book, *The Hollywood Commandments: A Spiritual Guide to Secular Success.*

Certainly, if you are obsessed with money and it's all you think about, you'll be willing to do anything to get it, including hurting other people. This unhealthy preoccupation with money does cause people to compromise their morals in pursuit of it. And here is a revelation: You don't have to be rich to be in love with money. In fact, I've met people at all income levels who are obsessed with money and what it can buy. I've also met people at all income levels who have a healthy respect for money yet are not obsessed by it. Do you glorify poverty? Do you demonize wealth? I can assure you right now, if you believe money is evil and poverty is spiritually superior, you'll always be living on the edge of broke.

Money is a medium for crafting the life of your choosing. Respect money as you do your other artistic tools and view it as a creative instrument. A professional artist will clean her paint brushes and take care to put them away. A professional musician treats his instruments with care and even reverence. He knows

that, if he disrespects his guitar and fails to tune it, his music will suffer. The same is true for money.

Whitney Cummings, author of *I'm Fine and Other Lies*, wrote an article for Time.com entitled, "I Didn't Understand Money so I Stopped Calling It Money." Like many of us, Whitney also had a dysfunctional relationship with money until she started calling it something else: freedom. She realized that more money meant she had more choices and therefore, more freedom. This shift in thinking also made it almost painless for her to stop wasting money on things that weren't important to her long-term happiness. She'll ask herself questions like, "Are these new jeans worth two hundred units of my current freedom?" or "Should I put some freedom into my 401(k) so I have some freedom when I get older?" The words we assign to money are extremely important to how we interact with our finances. So, if "money" still feels icky to say, consider substituting "freedom."

If you respect money and use it wisely, you'll have good results. If you disrespect money and misuse it, you'll have bad results. If a carpenter does a shoddy job building an addition to your house and it collapses in less than a year, you don't blame the hammer. It's important not to blame the only financial tool you have to work with—your money—and time to start respecting it and treating it right. You can create a masterpiece of a life by utilizing money like a brush to paint your dreams of adventure, security for your family, and generosity to others.

CREATIVE MONEY EXPLORATION

What was the attitude of your parents and other authority figures of money? Were you taught that money is evil and negative, or that money represents freedom and options?

For the next week, use the word "freedom" in place of "money" and note how that makes you feel about your finances.

CHAPTER 4

You + Money Sitting in a Tree

I remember being on the school playground at recess in grade school, boys on one side and girls on the other. If a boy bumped into a girl, hysterical screams of "Christine's got cooties!" would erupt and I spent the rest of the day trying to remove "boy germs." However, by the time high school hits, boys and girls trade notes and bat eyelashes at each other while the history teacher drones on about the Civil War. How did we go from dislike to dreamy eyes?

There's an awkward desert to cross in between, called middle school. Around the age of 12 or so, I remember my feelings about boys changing. Somehow, they seemed more intriguing and less annoying and gross. I'd spent so many years professing my disdain for boys that I felt weird and conflicted about this change. Wasn't I betraying my girlfriends by admitting that boys might be okay and possibly even lovable? Similarly, if you've spent the last 20, 30, or 40+ years of your life believing that money is gross, tainted, or evil, the process of learning to get cozy with your money is going to be an awkward transition. And that's okay.

I want you to think of money as your best friend or your best employee. You just felt icky reading that last sentence, didn't you? Yes, I want you to learn to thoroughly love and enjoy money and what it can do for you and your business. If you are stressed out because you're barely scraping by month after

month, it's hard to be a positive and present friend, parent, and lover. If you have a healthy and positive relationship with money, it will allow you to be generous and joyful. Shift your perspective of money from one of rivalry to one of partnership. You and money can accomplish so much good in the world together and have a riotously fun time in the process.

So, how is your current relationship with your money? Calm and sunny? Stormy and full of drama? Sad and stressful? You may not have thought about it this way before, but we all have a relationship with our money. Whether it is a positive or negative one doesn't depend on how much cash we have, but rather how we treat our money.

Think of your relationships in your life right now with your spouse or partner, children, friends, siblings, and parents. What are the keys to successful and happy relationships? I've found that there are three main keys to a positive relationship with anyone, or anything, including your money: respect, honesty, and positive attention.

RESPECT

If you don't respect your significant other, it's going to be nearly impossible to have a good marriage. Disrespect breeds a toxic environment in your home. Your significant other feels devalued and will likely distance himself or herself from you. Do you respect your money? If you don't, it will always flee from you! How can you tell if you're disrespecting your money? Here are some signs:

- If you have cash in your wallet, it is disorganized and wadded up.
- You have loose change accumulating in random parts of your house and car and you rarely, if ever, take it to the bank to cash it in.
- You have torn and crumpled receipts on the floor or your car, in your coat pockets, and on your dresser.
- Your bills are disorganized.

• Your purse or wallet is threadbare and falling apart.

How do you begin respecting your money? Ensure your cash is neatly folded in your wallet. When you make a purchase, take the extra few seconds to smooth out your bills and put them back where they belong. Have a designated spot for spare change, preferably in a nice container or piggy bank, and cash it in at the bank regularly. Keep both your receipts and bills organized and in a designated spot in your house and office. I know it seems strange that your money wants to be respected, but it does and it responds positively when you do. Create a cool and positive "work space" for your best friend and business partner, Money.

HONESTY

It's impossible to have a great relationship when you're lying to your partner or spouse. When you're not honest about your money, you're lying to yourself, which is a dangerous thing. We tell ourselves lies about our money all the time.

- "If I made as much money as my brother, I'd have it made."
- "I'll start saving for retirement next year when my business is doing better."
- "We NEED a new car because this old one is getting close to 100,000 miles."
- "I'll never be able to afford a vacation."

Here's the truth: every day we are choosing, consciously or unconsciously, how to use our money. Statements like the ones above make us temporarily feel better because we're putting the blame on someone else. We need to take responsibility for our behavior and thoughts now. We need to be honest with ourselves. No one else can change our relationship with money for the better except for us. Not even our next new product launch or big customer.

POSITIVE ATTENTION

You can't have a great relationship with your wife if you ignore her and never spend any time with her. This is a no-brainer when it comes to personal and even work relationships. Have you ever been under-appreciated or even neglected as an employee? How did you feel? We know if you want a great relationship with someone, you have to spend time with them and give them positive attention. The same is true when it comes to your money. Here are some signs you are neglecting your money.

- You frequently pay bills late.
- You've had multiple overdraft fees within the last six months.
- You don't know how much money is in your various checking, savings, and investment accounts.
- You are perpetually surprised when quarterly or annual bills come around, such as insurance, homeowner association dues, or car tags.
- Your credit score isn't good and you have multiple blemishes on your credit report.

I was certainly guilty of neglecting to give my money positive attention before I hit financial rock bottom. I wanted to stick my head in the sand, because I didn't want to know how bad things were. Guess what? They were bad! And they didn't start to improve until I started spending some concentrated time weekly and monthly with my money. How much positive attention do you give your personal finances on a weekly and monthly basis?

Every week, I take about 20 minutes to check my various accounts (personal checking, bill pay account, savings account, and my business account). Once a month, I take some extra time to check our spending plan and briefly discuss anything out of the ordinary with my husband. Once or twice a year, we meet with our financial advisor to discuss our investments. We also have annual conversations with our insurance broker and our tax

advisor. A relatively small amount of quality time spent on your business and personal finances pays big dividends. I promise you, if you ignore your money and don't give it any positive attention, it will always run away from you.

Commit to respecting your money and being honest with yourself about your finances. Invest some positive attention into your financial future. Money wants to be managed properly, and once you start doing it, it will grow seemingly like magic. Money problems are rarely about how much you have; rather the problem is your relationship with money. If you want to have more than enough money (freedom) to live your best life, stop treating it like your "frenemy" and learn to love money in a healthy and balanced way.

CREATIVE MONEY EXPLORATION

Note your response to the following statements.

1. Here's how I feel about money right now:
 I hate it.
 I dislike it.
 It's okay, I guess.
 I like money.
 I love money!

2. I respect my money by speaking well of it and giving it a good home.
 Never
 Rarely
 Sometimes
 Most of the time
 Always

3. I am honest with myself about the state of my finances, both business and personal.
 Never
 Rarely
 Sometimes
 Most of the time
 Always

4. I regularly give my personal and business finances positive attention.
 Never
 Rarely
 Sometimes
 Most of the time
 Always

What one or two things mentioned in this chapter will you commit to doing to improve your relationship with money?

CHAPTER 5

Unmasking Money Drama

In order to correct any negative thoughts, words, and emotions surrounding money, we first need to uncover them and bring them into the light. In her book, *You Are a Badass at Making Money*, author Jen Sincero proposed an intriguing exercise: Write a letter to money. Write this letter as if money is a person, and you're telling it exactly how you feel. Doing this uncovered my own money drama surrounding income generation in my business. Here's my letter:

Dear Money,

I feel like you are playing hard to get. When I do everything I know to make you, you barely trickle in. Sometimes, I'll ignore you and you show up in unexpected ways. It's just enough to keep me chasing after you. I'm afraid that if I don't have enough of you, my husband, Nick, will be resentful that I'm not contributing my fair share to the household expenses. I don't want to be a financial burden on him or anyone else.

I'm scared now that I have given up KRC (my family's business) as a source of revenue that I'll have to take a part-time job working for someone else to make up for it. I'd much rather earn my money empowering people to rescue their financial dignity through my coaching, courses, and books. This is the first time in my life that I don't have a reliable, steady source of you, which really freaks me out. I dislike not knowing where the

income's going to come from every month. I'm really tired of chasing you, Money. I really wish that you'd commit to being with me all the time. Please, please, please don't leave me!!

~ Christine

Here's what I learned from writing this letter:

I'm very good at managing the money once it comes in, but I was insecure in my ability to generate income consistently and in large quantities as an entrepreneur.

I was scared to be without a steady source of income, even one that sucked the life out of me.

I don't want to be financially dependent on anyone. Yes, I am fiercely independent and stubborn! But this baggage goes back to my relationship with my ex-fiancé, Jeff. I know what it feels like to be in a relationship with someone who doesn't contribute financially, and I don't want to be a burden on my husband, Nick. However, my husband is extremely supportive of me being an entrepreneur and has even said that if I want to be a stay-at-home mom to our cats, that's fine with him, too. (Yes, he's definitely a keeper!)

Now that I've brought this baggage out into the light, I can do something about it. Honestly, I'm still working through these issues, and I'm making some serious progress. I'm actively pursuing the development of new passive income streams for my business. I'm being bolder in my sales and marketing activities to generate new business and bring attention to my Financial Lifeguard brand. I've also re-read Jen Sincero's, *You Are a Badass at Making Money*, at least a dozen times. In fact, I'll keep it in rotation until I can say without a shred of doubt in my voice, "I AM a money-making badass!!"

Although I'm still not 100% comfortable with it, I keep telling myself that it is not just okay, but a wonderful thing that my husband wants to take care of me financially. This doesn't make me a weak or helpless woman to be cared for by Nick. In fact, it makes me very lucky! This revelation has shown me that I need to work on being a gracious receiver. When I receive and appreciate what is given to me, I am blessed and so is the person

who is giving to me. *Receiving is not the same thing as taking.* Maybe some of you need to hear that, too.

I've decided to reframe my fear of the unknown as an exciting adventure regarding my income. Fear says, "Oh my God, I have no idea where my income is going to come from this month! I hope I don't have to dip into my savings to pay the bills." Excitement says, "Oh my God, I am so stoked to see what opportunities and new business deals come my way this month! I better make room for all the money that's flowing in!"

CREATIVE MONEY EXPLORATION

Create something in your artistic wheelhouse that conveys how you currently feel about money. Write a poem, short story, song, one-act play. Or write a letter to money, as I did. Draw, sketch, or paint a picture representing your current relationship with money. Bonus points: Use hashtag #CreativeMoneyExploration and post on social media and tag me (@FinLifeGrd) or email me at Christine@ChristineLuken.com.

CHAPTER 6

You and Money Can Change the World

D o you have a push-pull relationship with money? Many of us do. We say we want more of it, yet at the same time it feels dirty or wrong to want it. Because surely if we have more money than we need, that somehow makes us one of those evil, greedy, rich people. Whether we like it or not, money is a source of power in our society. Yes, undoubtedly there are people who use that power to exalt themselves and oppress others.

However, if the kind, loving, creative people of the world shun money, we're handing our freedom and power over to the cruel and selfish ones in our society. If you (one of the kind, loving, creative people, obviously) have more financial resources, you not only take better care of yourself and your family but also, you'll have increased opportunity to support socially conscious companies and charities. Just think of all the positive changes that people like Bill and Melinda Gates, Oprah, and Ellen DeGeneres have made with their fortunes. Money is power, and you can choose to wield it as an instrument of positive change.

Let's say that you are passionate about climate change and being a responsible citizen of our beautiful planet Earth (which we all should be, in my opinion!). You want to drive an electric

car. You would love to only wear clothing that is responsibly produced and made of organic or recycled materials. You have a passion for helping others and want to give money to charities who rescue animals, help the poor, and provide medical care for people in third-world countries. However, if you can barely afford your own rent, car payment, and groceries, you can't do any of those things. Your car is a gas-guzzler that expels noxious fumes as it chugs down the road in fits and starts. You can only afford to shop for clothes at the local big-box store, knowing that their clothing is not produced in a socially or environmentally responsible manner. You feel like a hypocrite, yet your lack of money is dictating your current choices.

By becoming financially successful in your business and personal life, it gives you the power to do more good in the world. You can patronize businesses that have excellent products plus a mission which resonates with you. You can support other artists by buying their music, going to their plays, and purchasing their paintings. You have the opportunity to give from your abundance to the homeless man begging on the corner or the hungry child halfway around the world. However, it's hard to do any of this if YOU are not financially healthy.

CREATIVE MONEY EXPLORATION

Find a financially successful role model who is generous and using their financial resources to make the world a better place. This could be someone you know personally or a celebrity. What is it specifically about this person that you admire?

Which socially or environmentally responsible companies, artists, and charities would you like to patronize on a regular basis?

Go online and find pictures that represent them. Print them out and put them where you'll see them on a regular basis.

CHAPTER 7

We're Not Worthy

You are worthy of money and success! "I don't think so," you might be saying. Why is it that we struggle so much with the issue of self-worth and the worthiness of our art and work? I think there's a multitude of reasons for this, including fear of judgment, narratives from our past, and even the fear of success. Sometimes, it's easier to stay mired in the cesspool of anxiety and angst about our value than to climb out and take action. If we take action and create, we're opening ourselves up for judgment. When a potential customer claims that our photography prices are too high, we may internalize that as the unspoken, "Who do you think you are to charge that?" Even though the person simply means they personally cannot afford your rates.

We may hear a harsh parental voice in our heads: "You'll never amount to anything!" or "You can't support yourself with a music degree." It's vitally important that we remove these negative narratives by capturing them on paper and rewriting them as positives. Is it really true you can't support yourself with a music degree? Find someone who is financially successful in your artistic field and see how they did it. "If Caitlyn can financially support herself as a musician, so can I." Read or listen to the life stories of successful artists and musicians for clues. It's rare that raw talent alone leads to a fulfilling and financially stable artistic career. You'll find a high level of

production and networking can cause a less talented artist to make more money than an artist with a high level of talent and low levels of ambition. And by the way, "ambition" is not a dirty word. Dictionary.com defines ambition as: "an earnest desire for some type of achievement or distinction, and the willingness to strive for its attainment."

Ambition = Desire + Production

It's easier to stay broke and complain about the state of the world than it is to get rich and put your money where your mouth is. With wealth comes responsibility, and that scares us. When you say, "I don't deserve money," *you are rejecting your own power to change the world for the better*. The world needs your art, now more than ever. Even more importantly, the world needs your artist's heart more than ever. When we view becoming financially healthy—and yes, even becoming wealthy—as our duty to our family, our community, and the planet, great positive change will happen. You are a gift to the planet, but only you can remove the wrapping. What are you afraid of: judgment, success, responsibility, or something else?

I recently read a wonderful book called, *Worthy: Boost Your Self-Worth to Grow Your Net Worth*, by Nancy Levin. This book really digs deep to uncover the negative beliefs that hold us back from becoming and staying financially healthy. It's very interesting because sometimes there are situations from our past which have nothing to do with money, yet they're affecting our finances.

I'll give you a personal example I worked through recently. I felt like there was something holding me back from being in the spotlight even though I was doing all of the right things to gain publicity. I finally traced it back to a time in my childhood when it felt scary to be the center of attention. I moved to a new state in the middle of my 3rd grade year, and unfortunately, I was teased, ignored, and bullied by the kids in my new school. It was the first time in my life that it wasn't safe to be seen. I had no idea that my "inner child" was still trying to protect me from being seen because she didn't feel it was safe to be the recipient

of attention. This was directly affecting my income, because if no one sees you, they can't buy from you!

Working on our worthiness issues isn't just a one and done event. It's like peeling away the layers of an onion. But with each revelation of what's holding us back, we can choose to engage in the process and grow from it. We can exercise compassion for ourselves, and as we learn and expand, so do our feelings of self-worth.

"Our deepest fear is not that we are inadequate. Our deepest fear is that we are powerful beyond measure. It is our light, not our darkness that most frightens us. We ask ourselves, 'Who am I to be brilliant, gorgeous, talented, fabulous?' Actually, who are you not to be? You are a child of God. *Your playing small does not serve the world.* There is nothing enlightened about shrinking so that other people won't feel insecure around you. We are all meant to shine, as children do. We were born to make manifest the glory of God that is within us. It's not just in some of us; it's in everyone. And as we let our own light shine, we unconsciously give others permission to do the same. As we are liberated from our own fear, our presence automatically liberates others." (Marianne Williamson, *A Return to Love: Reflections on the Principles of A Course in Miracles*) (emphasis mine.)

CREATIVE MONEY EXPLORATION

Identify a successful creative in your field and, if possible, ask them how they did it. Celebrities are much more accessible now in the age of social media. And everyone loves to tell the story of how they overcame the odds and figured out how to make it in their field. Or read a biography of someone who made a financially successful career creating your type of art.

CHAPTER 8

Permission to Be a Professional

I had an interesting conversation with my friend, Ashley Peacock, a musician, producer, and owner of Soul Foundry while writing this book. As a mentor to aspiring musicians, one thing he finds himself saying to them over and over again is this: *"Give yourself permission to be a professional."* Creative entrepreneurs aren't the only ones who have an issue with this. I've seen it in my friends, colleagues, and coaching clients who are attorneys, real estate agents, and brick-and-mortar business owners.

Giving yourself permission to be a professional means you are taking yourself and your business seriously. This isn't a "jobby," a hobby you sometimes get paid for doing. People who have given themselves permission to be professionals behave differently from amateurs.

Professionals speak confidently and unapologetically about their business, skills, products, services, and pricing. There's nothing worse than asking an amateur about their business and having to suffer through a mumbled, apologetic explanation of their services. If they're not excited about what they're selling me, I'm wary about buying from them.

Pros are not afraid to invest in coaching, seminars, and classes that will improve the professionalism of their business and brand. Professionals are always learning, growing, and stretching. What will set you apart from others in your field? If

you need to obtain particular certifications to ratchet up your professional presence, then invest the time and money to do it. Read books and take classes on how to network and speak professionally, especially if that's not the norm in your field. Amateurs are cheap when it comes to investing in themselves and their business ventures.

Professionals look the part, both in person and online. Your clothing, body language, tone of voice, marketing materials, and digital presence are all conveying a message. The question is, "What message am I sending?" We'll dive deep into your professional image later in the book because it's vital to your success.

I'm currently working with a phenomenal business coach, Jenn Scalia, who helps women wanting to grow their coaching practices online. One of the most powerful exercises in her "Wealth from Within" program is called, "Stepping into the Identity of the Future You." I was tasked with imagining the following about my future self, who I dubbed "Christine 2.0" (but I now refer to her as Queen Christine): How does she act differently? What habits does she have in place? How does she make decisions? What does she say yes (or no) to right now? *So, here's the big question:* Why not start acting like that right now?

I would encourage you to ask yourself these same questions. Now, as I go about my workday, especially if I'm feeling uncertain about myself or what to do, I ask, "What would Queen Christine do?" She'd be kicking ass and taking names, that's what. And she'd definitely be giving herself permission to be a professional. If you don't look and act like a boss, you're not going to get paid like a boss.

CREATIVE MONEY EXPLORATION

Write a story of a day in the life of Future YOU. First give yourself a new moniker for Future You, whether it's Simon 2.0 or Mighty Michelle. How would YOU 2.0 go about your day? What customers would YOU 2.0 be serving? How would YOU 2.0 be managing money? Who would be part of your inner circle? What things would YOU 2.0 be doing? What would YOU 2.0 be delegating? How would you feel wearing the skin

of YOU 2.0? Create a vision board (physical or electronic) that represents YOU 2.0 and your business.

CHAPTER 9

When to Make the Leap

It's rare that a creative graduates from art school and immediately starts their own business. Most of us start off with our creative business as a side hustle, which eventually leads to our full-time profession. Personally, I never intended to be an entrepreneur or self-employed. I thought financial coaching would be my way of giving back to the community. I began as a volunteer, helping people at my church to become financially healthy.

But as it often does, the creative hobby or volunteer activity evolves into a side business that grows into a full-time enterprise. A question I'm frequently asked is this: *When* do I make the leap from side-hustle to full-time entrepreneurship? You want your transition to be as smooth as possible, so here are some factors to consider.

Are you turning away work in your side business because you don't have the time or energy to fulfill the demand? This is a sure sign that you're approaching the point of leaving the day job for entrepreneurship! Your products or services are in demand and the only thing holding you back is the lack of time to produce and service your customers. By freeing up some time, you'll be able to easily replace your former job's salary if you're currently turning away work.

Are you beginning to resent your day job because you'd rather be working in your creative business? Totally been

there! And it's not a fun place to be. Every waking hour you're at your "real job" becomes drudgery, because all you can think about is the amazing things you could be doing with your creative business. If you're wrestling with this very same issue of when to quit your day job, I highly recommend you grab a copy of Jon Acuff's fantastic book, aptly named, *Quitter: Closing the Gap Between Your Day Job & Your Dream Job*. In it, Acuff shows you how to use your day job as a launch pad for your business, rather than viewing it as an anchor that's dragging you down.

Are you earning almost as much money or more in your side hustle as your day job? If so, way to go, boss! Shelly Byrne, business coach and co-founder of Earthjoy Tree Adventures, advises her clients to consider leaving their day job behind when they're making 75% of their regular salary with their side gig. You've proven that your business is viable and there's demand for your products and services. If you have a solid personal financial situation, you might consider leaving Corporate America when your side hustle is paying you less than 75% of your day job salary. What if you're not making that much yet? When I quit my job to pursue entrepreneurship full-time, I made about 50% of what my day job paid me. BUT, I had no debt other than my mortgage, and my husband and I accumulated more than a year's worth of salary in our savings. We also trimmed our monthly bills and paid down our mortgage and refinanced it to a lower payment. Speaking of which...

Are your personal finances on solid ground? If not, the deck will be stacked against your success before you even start. Nothing is more critical than getting your personal financial house in order. And if your business is already up and running, ensuring your personal finances are rock solid will directly impact the success of your creative venture. Why? Although we hear financial experts tell us to keep our business and personal finances separate, the truth is that it's impossible for them not to influence each other.

If you have careless, sloppy personal money habits, it will affect your creative business. If your business is having a terrible quarter, that directly impacts your personal bottom line. The best

money move you can make for your business is to ensure that your personal financial situation is on solid ground. I love the way Mel Robbins, author of *The 5 Second Rule*, explains it. She says that to have a successful lift off for your business requires a sufficient "financial runway." I can tell you from personal experience, it will take you more time and effort than you think to ramp up your business and produce the income you want. It's just part of the grand adventure of being self-employed!

Here is what I recommend for my coaching clients who want to start their own business: six to twelve months of living expenses in their emergency savings, little to no personal debt outside of a mortgage, minimize personal recurring expenditures, and know exactly how much needs to come in from the business monthly to cover your personal necessities.

If you answered a resounding "yes" to the questions in this chapter, then it's time to hatch your escape plan from your day job. If you answered yes to some, but not all, of the questions, you likely need some additional time to build up your income and ensure your "financial runway" is sufficient to launch your business successfully.

CREATIVE MONEY EXPLORATION
Which questions did you answer "no" to, if any? What do need to do to turn them into "yeses"?

PART TWO

The Art & Science of Managing Money

CHAPTER 10

Know Your Numbers

You might be thinking, "But I hate math! Numbers are not my thing." You don't need to master calculus to have a basic understanding of your financial information. The numbers tell a story and give you vital information to make good business decisions. The first step to making numbers less confusing is to *stop* saying that you hate accounting and can't understand it! Many professional accountants make the subject much more complex in an effort to impress you, and possibly confuse you, as a means of persuading you to hire them. I'm not advocating that you keep your own books if math is not your strong suit. However, it is important for you to understand the basics of business accounting for several reasons.

First, accounting gives you the vital statistics of the financial well-being of your business. Just as your weight, cholesterol, and blood pressure numbers tell a story about your physical health; your sales, profit margin, and cost of goods sold numbers tell a story about the financial health of your business. Second, a basic understanding of accounting will help you make wise decisions in your business. You'll be able to see the direct connection between your operational activities and how they affect your bottom line. Third, a basic understanding of accounting will assist you in communicating with and evaluating the accounting and tax professionals you decide to hire in your business.

Recently, a client of mine, Jack, asked me to help him "straighten out his QuickBooks account." My client suspected his bookkeeper, Sam—whom he hired at the beginning of the year, wasn't doing a good job because Jack wasn't receiving regular reports from him. Normally, I don't do bookkeeping work for my financial coaching clients, as I'm focused on reviewing financial information, helping them identify trouble spots, and suggesting actions for improvement. However, I made an exception for Jack, and he gave me access to his QuickBooks Online account.

To my horror, I discovered that Sam had not classified *any* of Jack's financial transactions in almost seven months! My client was paying this bookkeeper $500 a month and getting nothing in return! After slogging through all the numbers side-by-side with Jack to ensure everything was properly classified, we discovered he had an operating loss. Had he known this sooner, Jack would have been able to take corrective action immediately.

The lesson here is this: Know your numbers! It's important to review them at least monthly with your CPA or bookkeeper if you're paying someone to do it for you. What you focus on improves. If you pay attention to your sales, expenses, and profit, chances are good you'll make progress. You can't fix something if you don't know it's broken.

In the chapters that follow, I'm going to give you a basic understanding of the important accounting numbers you need to know to ensure your business is financially healthy. I promise, it won't be hard or scary! What's really scary is being in the dark about your business finances and being at the mercy of someone else who may (or may not) have your best interests at heart!

CREATIVE MONEY EXPLORATION

On a scale of 1 to 10, how competent do you feel you are with your business accounting? (1 = Not at all; 10 = I totally rock it.)

In what ways has your inattention to the numbers in your business cost you in time, money, or bad decisions?

CHAPTER 11

Give Your Money a Good Home

An artist who prefers to remain anonymous confessed to me, "I don't like tracking expenses, receipts, and other paperwork for my accounting and taxes. I'd like to have an organized system for tracking my business accounting, but the thought of setting it up just paralyzes me. Right now, I have a plain brown box that I dump receipts into on my desk. When it gets full, I dump them into a trash bag and put it in my closet. It makes me feel better that the box is empty, and I don't have to look at all those receipts, which will eventually need my attention come tax time."

If you want money to hang out with you in large quantities in your business, you must give it a good home! This means having a designated bank account and a filing system for your financial records. Do you think money feels respected by the artist who stuffs her financial records in a garbage bag and shoves it in the closet? Probably not. This negative energy is likely keeping her from making the income she desires.

Maybe you dread financial record keeping, as many creatives do. As Monica Tuck, owner of Unbridled Studios, told me, "Business budgeting and personal finance seem boring. There's always something more exciting I can do instead!" Honestly, despite being a "numbers person," it's not my favorite thing either. Managing your financial data is vital to your business success, so I'm going to help you do it in a way that's

not only respectful to your money but maybe even enjoyable for you as well.

First, and most importantly, you must treat your business as a separate entity and ensure you have a designated bank account in which to deposit your income and pay your expenses. Larry Nitardy, Principal at ComAssist Business Coaching says, "You minimize the importance of your business, and thus disrespect it, when you mix it with your personal finances." You also make it very difficult to determine how well your creative business is doing if you don't keep it separate.

Thankfully, accounting in the electronic age is much simpler and easier than it used to be. Online banking and programs like QuickBooks take much of the work out of business accounting. When I talk to business owners about their record-keeping, most agree these tools seem like a good solution, but they're intimidated by the learning curve and the set-up. The wonderful thing is that this can easily be outsourced to your accountant or CPA.

When I am working with an entrepreneurial coaching client, we'll take one of our sessions to get them up and running with one of these online tools if they're not already using one. Once I show them the ropes, they're confident they can manage it going forward. If you're avoiding using a tool like QuickBooks Online because of the intimidating set-up, it would benefit you greatly to pay a numbers nerd to help get you established and trained.

The beauty of using a cloud-based accounting program is that it automatically pulls in your transactions from your bank account. This saves major amounts of time because there's no data entry, plus it vastly reduces the amount of paperwork in your business. You can take pictures of your receipts with your phone and upload them to your accounting program via an app.

Yes, you'll still have paper copies of important financial documentation for your business. So, how do you tame the paperwork monster? Set up a very simple filing system by month or by quarter, depending on the volume of your transactions. Rather than putting your receipts in a shoe box (or a garbage bag in the closet), go to the office supply store and buy yourself some colorful file folders and a cool "in box" to contain your

paperwork. I'm a big fan of "fancy" office supplies, because they make it a little more fun to do the business tasks which have to be completed one way or the other. It's worth the few extra bucks, if you ask me!

Currently, I have file folders for invoices, bank statements (and supporting receipts and deposit slips), expense reports (mileage I reimburse myself for out of the office business), and financial statements. Some business owners simply have one file folder per month for all their business paperwork. If you have vendors that you are regularly paying with checks, I would designate a file for their invoices. As invoices and receipts come in, I put them in the appropriate file rather than let them accumulate on my desk. Only invoices to be paid are on my desktop, with the ones due first on top. That way, I just glance over and see if anything needs to be paid in the coming week. Pretty simple, right?

By handling the paper copies you need to keep right away and tossing the ones you don't, piles don't grow out of control. You'll have everything your accounting professional needs from you to file your taxes and other reports in a timely manner. Is your spouse or teenager super detail-oriented? Use this to your advantage by having them organize your paperwork and match receipts to your bank statement.

Think of this as redecorating and organizing your money's home. If your business and personal finances are living in the equivalent of a bare studio apartment with a card table, folding chair, and a single light bulb hanging from the ceiling, it's time for some upgrades!

CREATIVE MONEY EXPLORATION

Go online or to your local office supply store and buy file folders and other supplies you need to organize your business and financial paperwork. Pick colors and designs which make you smile! And if your purse or wallet looks like it should have been thrown in the trash six months ago, get a new one that appeals to you... and your money.

Don't have a separate bank account for your business yet? Pick a day and time this week to go to the bank and open it.

Get yourself set up on an accounting program like QuickBooks Online, Xero, or FreshBooks. Enlist the help of a numbers nerd if this scares you. For that matter, your bank might even be able to help with this.

CHAPTER 12

The Language of Money

The language of money and business accounting tends to be confusing to non-financial people, in the same way that creative terms can be baffling to non-artists. Case in point: a good friend of mine, Ashley Peacock, is a musician. We have great conversations about business, life, and spirituality. However, when he's around other musicians, I feel totally unqualified to enter into the conversation, because I honestly don't understand half of what they're saying! You might feel the exact same way when others are talking about matters of business finance. I'm going to do my best to demystify accounting, which is really just the language of money.

Seven years ago, I decided to take a painting class to prove to my friend, Kim Vanlandingham, that I could NOT paint. Kim is a painting teacher and she told me that she could teach anyone how to paint, so long as they would be willing to listen and follow directions. I advised her that I could barely draw stick figures and saw this as an opportunity to prove her wrong. But, after just one class, I was hooked on oil painting, and am still taking Kim's classes all these years later. However, it took me a while to learn both the language and techniques of painting. I remember how timid and awkward I felt in the early days. I asked what I thought were stupid questions like, "Is the yellow ochre paint the mustard color or the sunshine color?" "Is there a difference between liquid white and Liquin?" What's the point

of me telling you this story? If you're feeling intimidated and overwhelmed about the mechanics and language of managing money, you're not alone. Be patient with yourself because learning this stuff is a process.

Here are the basics of business accounting that you need to know, in plain English.

ASSETS (WHAT YOU OWN)

Assets are simply things of value you *own* in your business. Cash in your business checking account is an asset. Outstanding customer invoices (also known as "Accounts Receivable" because you will be receiving the money) are assets. The tools you use over and over again in your business to produce and deliver your products and services are assets.

These can include things like company vehicles, computer equipment, buildings, and production equipment. For a musician, assets may simply be cash, customer invoices, a laptop, guitar, and sound equipment. You might hear accountants and CPAs refer to certain assets as "liquid." If an asset is liquid, it means it's easily converted to cash. Cash itself is the definition of liquid, but customer invoices and other assets that convert to cash easily are also considered liquid.

LIABILITIES (WHAT YOU OWE)

Liabilities are what you *owe.* Any amount of money your business owes to another person, bank, or company is a liability. Bank loans, credit cards, car loans, lines of credit, building mortgages, or business loans from friends or family members are liabilities. Outstanding invoices from your vendors (also known as "Accounts Payable" because you will be paying the money) are liabilities.

For an artist who makes organic scented soy candles, liabilities might include a credit card balance, a few vendor invoices, and sales tax collected from customers which will be paid to the state at the end of the quarter. You might hear financial gurus discuss long-term versus short-term business liabilities. Short-term liabilities are those that must be paid within a year or less (like vendor invoices and credit card bills),

while long-term liabilities are those that won't be paid in full for more than twelve months (like car loans and building mortgages).

EQUITY (VALUE)

The equity in your business is simply your assets minus your liabilities. Equity = what you own - what you owe. Hopefully, that number is positive! You might also hear it referred to as "Owner's Equity." The goal of every business owner (whether entrepreneur or big box business) should be a profitable business that builds equity!

INCOME (SALES)

This is the fun stuff! Income (also known as "Sales") is the amount your customers pay you in a given time period. Income can flow in from multiple sources, such as billing clients for hours worked, selling your products or services, affiliate income, or receiving royalty payments for your pictures, songs, or books. Income is also referred to as your "Top Line." Why? Because your sales number is at the top of your income statement.

You might hear accountants refer to income or sales as "Gross" or "Net." "Gross" doesn't mean your income was derived through disgusting means, such as pumping out septic tanks or mucking horse stalls. "Gross Sales" is simply your total amount of income before sales-related costs, which are typically commissions, referral fees, or affiliate bonuses. "Net Sales" have nothing to do with basketballs or butterflies. "Net Sales" is your sales number after subtracting commissions, referral fees, or affiliate bonuses. If you don't pay out commissions, referral fees, or affiliate bonuses, then your Gross Sales and Net Sales should be identical.

COST OF GOODS SOLD (DIRECT COSTS)

Cost of Goods Sold (often referred to as COGS) are costs directly related to the production and delivery of your product or service. If you don't sell anything, these costs do not occur. For example, if you're a painter who has been commissioned by a

local hotel to paint a large canvas with the city skyline for their lobby, your supplies for this job are "Cost of Goods Sold." The canvas, frame, and any paint or supplies purchased specifically for this project are your COGS. For someone in a service business, like writers, coaches, photographers, and wedding planners, there may be very few expenditures considered to be Cost of Goods Sold. When I purchase my books from the printer to sell to others, this is one of the few COGS expenditures for me.

EXPENSES (INDIRECT COSTS)

Expenses are things you buy for your business that are not directly related to the production and delivery of your products or service. Sometimes they are referred to as Selling, General & Administrative Costs (SG&A). In the example above with our painter, some of his general expenses might be the rent for his studio, his monthly cell phone bill, advertising on social media, and web hosting fees. These are simply expenditures that are going to occur whether you sell anything or not. You also might hear them referred to as "Overhead." Can you see why the language of accounting is so confusing? We have at least two or three terms for the exact same thing!

PROFIT

Profit − Sales - COGS - Expenses. Your profit is what's left over after you've paid all the bills out of the income you've received. If your sales are more than enough to cover your costs, you have a business profit. If your sales don't cover your costs, then you have a loss.

See, that wasn't so scary! To recap, here are the important business accounting terms you need to know:

Assets = What You Own
Liabilities = What You Owe
Equity (Company Value) = What You Own - What You Owe
Income = Sales
Cost of Goods Sold (COGS) = Production Costs

Expenses = Non-Production Costs
Profit (or Loss) = Sales - COGS – Expenses

CREATIVE MONEY EXPLORATION

Think back to a time when you tried to describe the technical terms of your art to a non-artist. Chances are, you gave them a patient explanation of the basics. Commit to showing the same compassion for yourself as you learn the basics of business accounting.

CHAPTER 13

Financial Statements: Your Business Score Card

U nderstanding your business financial statements is vital because they're essentially the score card which shows you if you're winning or losing the money game. I'm giving you a simple overview of the three financial reports you'll need to monitor at least on a monthly basis: the Income Statement, the Balance Sheet, and the Cash Flow Report. The examples here are overly simplistic for a reason. I want you to sit down with your accountant or CPA and look at *your* financial statements once you have a basic understanding of each report. If I give you overly complicated examples that have nothing to do with your business, you're going to become bored, or confused, or both! And we don't want that. If you want to do your own accounting and need to learn more about the details, there are great books out there which will help you. This, however, is NOT that book! If you'd like such a book, I recommend getting a physical copy of *Rockin' Your Business Finances* by Christine Odle. It is a workbook which walks you through all of this with your own business numbers.

INCOME STATEMENT:

In my opinion, the Income Statement is one of the most vital financial reports for your business. It shows you if your business

is making money or losing money. You definitely need to run this report at least monthly. The Income Statement is your Income (or Sales) minus your Cost of Goods Sold and your General Expenses. IF there is anything left over, this is your Profit. If your costs exceed your sales for a particular month, you will have a Loss. Let's say that Joanna, a branding expert and web designer, earned $7,000 in June. Her total expenses for the same month were $2,000. Joanna's profit for June is $5,000. Pretty simple, right?

BALANCE SHEET:

The Balance Sheet shows you three things: your Assets (what you own), your Liabilities (what you owe), and your Equity (the difference between what you own and what you owe). If your Assets exceed your Liabilities, which I hope they do, then you have positive Equity in your business. See, nothing scary or complicated here.

CASH FLOW REPORT:

The Cash Flow Report is all about the *timing* of your inflows (Sales) and your outflows (Cost of Goods Sold and Expenses). There may be times when you sell something but don't receive the payment from your customer right away. A photographer, Dave, may do a family photo shoot on a Saturday in the park and expect his customers are going to pay that day by check or credit card. However, when he goes to a corporate client location to take 45 head shot photos for their employees, Dave will submit an invoice. That company may pay all of its vendors 30 days after the invoice date. So, Dave might issue the invoice to his corporate client and log the sale in January, but not receive the payment until February.

The Cash Flow Report helps to identify the ebbs and flows of your business cash. It is possible to be profitable according to your Income Statement, but to have no cash in your business checking account because you're waiting on your customers to pay your invoices. We'll talk about how to increase your cash flow in a future chapter, so these "cash crunches" happen to you less often.

Are there other financial reports that you can run for your business? Absolutely! You can print a multitude of reports on sales data, accounts payable and accounts receivable, tax liabilities... blah, blah, blah! In fact, I just counted the total number of reports available to me in QuickBooks, and there are 67! Guess how I many I use? Five. Your bookkeeper or CPA will direct you to any additional reports you may need to reference on a regular basis for your business outside of the Big Three: Income Statement, Balance Sheet, and Cash Flow Report.

CREATIVE MONEY EXPLORATION

Print your most recent income statement and balance sheet for your business and look them over (with your CPA or bookkeeper if you have one.) Do you understand these reports better now that you know what each of the terms means? If not, ask your numbers nerd for an explanation of anything that's still confusing to you.

CHAPTER 14

The Income Roller Coaster

I f your income varies from month to month, creating personal and business spending plans can be a seemingly impossible task. Creative entrepreneurs face unique money challenges when some or all of their household income varies from month to month. When business is great, life's a party and we're booking cruises to the Bahamas. When sales are down, we're eating Ramen noodles and dodging collector calls.

I've had coaching clients tell me, "I can't do a monthly spending plan because, I have no idea what my income is going to be!" The truth is that those with variable income desperately need a solid plan so they can smooth out the highs and lows and get off the income roller coaster.

Budgeting with variable income has some extra steps to it, but it isn't complicated. The first thing you need is to clearly understand your family's personal monthly expenses. How much does it take to pay your basic household bills every month? Look at the history over the last 6 months to a year from your bank statements and credit card bills.

Unlike those folks with a steady monthly income, your spending plan will have two parts: The Base Budget and the Overflow List. The Base Budget includes everything that *must* be paid in a given month: house payment/rent, car payments, gas, utilities, basic groceries, minimum due payments on credit cards, etc. The Base Budget will tell you how much money you

need to bring in at a minimum each month and gives you a baseline income goal. If you are fortunate enough to have a spouse or partner with steady income, as I do, your Base Budget can be established on the amount of income you *know* will be coming in, no matter what.

The Overflow List is your "wish list" of items you want to take care of if your variable income is greater than your Base Budget total. You would include things like vacation, paying extra on debt, adding money to the savings account, entertainment, and the like. There are two ways you can handle your Overflow List. You can write out the items with set dollar amounts for each one, or you can assign a percentage to each item on the list, totaling 100%. If your income is above your Base Budget for the month, you'll already have a plan for that extra income. The Overflow List will show you exactly where the money will go.

CREATIVE MONEY EXPLORATION

Please reference the Manage Money Like a Boss Workbook to see an example of the Base Budget and Overflow List.

CHAPTER 15

Your Financial Anti-Anxiety Pill

Wouldn't it be great if you could pop a pill and all your money worries would just melt away? Of course, I'd be a billionaire if I were to invent such a pill... Unfortunately, there's no medication that will magically make your financial anxiety disappear. However, you have much more control over your money worries than you might think.

One sure fire way to drastically decrease your money anxiety is to have an emergency fund, both personally and for your business, with enough to cover six months or more of your expenses. Yes, that's right: six months or more of your expenses in a savings account. When you operate your business or personal finances with little to no savings, you have no room for error and no contingency plan when things go awry. If a big customer doesn't pay on time, it could cramp your business' cash flow and your bills go unpaid. A major car repair might need to be charged to a high interest credit card if your savings account is empty. Even reading about these events is enough to raise your blood pressure!

I know because I used to live this way. I walked around with a constant cloud of money anxiety hanging over my head when I had no savings. And that anxiety would spike when emergencies like vet bills and car repairs inevitably cropped up. Life happens! We will all have these occasional money emergencies. However, when you have a nicely padded savings

account, these emergencies are dialed down to minor inconveniences.

If you don't have a personal or business savings account, today is the day to rectify that! Systematically begin putting a percentage of your income into savings before paying any of the bills. If you can set up automatic transfer to your savings account, even better. Slowly but surely, you'll begin to feel your financial anxiety ebb away as your savings account grows, no pills required!

Many businesses have a line of credit or "sweep" account with their banks. Essentially, a sweep account ensures the main business checking account has a steady balance in it. If the account dips below this predetermined balance, the sweep account adds money to plump the value back up. If the account starts to get "fat," it sweeps money away, paying down the line of credit.

It's a smart idea for anyone who has variable income to maintain a personal sweep account. This is different and separate from your emergency fund. (I advise all my coaching clients to have six to twelve months of living expenses in their emergency fund.) A personal sweep account is different in that you are either pulling from it or depositing to it every month in an effort to smooth out your variable personal income.

Before they come to see me, my financial coaching clients with variable income are often living in feast or famine mode. When business is great, life is a big party! When business is lean or non-existent, there's barely money for essentials and bills may even go unpaid. The purpose of the personal sweep account is to maintain a steady standard of living and smooth out those harrowing highs and lows.

It does take some discipline to establish the personal sweep account, because you must consciously fund it in your prosperous months so it's available to pull from in the lean months. How do you calculate the ideal amount to keep in your sweep account? Let the past be your teacher by studying your cash flow history. What was the worst stretch of bad months you had in a row? How many months last year did you bring less than necessary to cover your family's living expenses? How

much would the total shortfall be if all those months happened in a row? Answering these questions will give you a good feel for an appropriate amount to have in reserve. And don't forget, if you pull from your sweep account this month, you'll need to replenish it with your next prosperous month!

Yes, it does take some time, effort, and self-discipline to set up and maintain a personal sweep account. The payoff is that you'll remove yourself from the emotional roller coaster that many entrepreneurs ride each and every month.

CREATIVE MONEY EXPLORATION

Don't have a savings account? Go to your local bank or credit union and open one up. Or open one online and set up automatic transfers every month.

CHAPTER 16

Multiple Streams of Income

When I talk about having multiple streams of income, I'm not asking you to take on a side hustle, join a direct sales organization, or start another completely unrelated business venture. Certainly, you can do any of those things if you want to scatter your energy, but I'm a firm believer in the power of focus for business success. Just because you are focusing doesn't mean you can't have multiple closely related streams of income that support your core business identity. And you will likely need multiple streams of income as a self-employed creative to be financially prosperous.

In the process of working with my first business coach, Nanette Polito, I realized my mission was to empower as many people as possible to rescue their financial dignity. There are three main ways I do this: as a coach, speaker, and author. I coach individuals, couples, and small business owners in person and online. I speak to groups on a wide range of financial wellness topics. I write books and blog posts to equip people to tackle their emotional money challenges. Although I have multiple streams of income, they are all laser focused on one thing: helping others to become financially healthy. If you need to activate additional streams of income, focus on ones that closely support your business mission and your brand identity.

I was guilty of violating this maxim when I first became self-employed. Honestly, I felt like I needed to do anything and

everything just to pay the bills. Here were some of the things customers were paying me for: writing website and sales copy, editing books, managing social media accounts, organizing online giveaways, and bookkeeping. What's the issue? None of those activities supported my mission of helping others to recover a healthy relationship with their money. Yes, these gigs paid the bills, but they also took precious time away from my core mission. It also confused potential clients as to what I did. "Wait, so you're a money coach, an editor, a social media manager, a copywriter, *and* a bookkeeper?" It took feedback from my business coach to realize this scattered approach was damaging my credibility and probably causing me to lose potential coaching clients.

Jen is an artist who also teaches others to paint via group classes at her studio. Customers purchase her paintings, pay to take her instructional painting classes, and commission her to paint specific pieces for them. If Jen needed to open up additional streams of revenue, she could paint murals on walls in people's homes, apply for a position with an art museum, or work for an interior decorator. All of these activities would support her identity as an artist and increase her income. They would also put Jen in proximity with people of influence who may hire her as their painting teacher or purchase other art from her. If Jen chooses to take a part-time job that has nothing to do with art, that's fine. Sometimes you have to do that, but don't dilute your brand identity by talking about it like it's your main business. If Jen works two days a week for a mortgage lender answering phones and doing clerical work to make extra income, she doesn't start identifying herself as a receptionist. She's an artist. Period.

Business opportunities will come your way, and you're going to have to decide whether to pursue them as income streams. I recently had the pleasure of hearing Mel Robbins, author of *The 5 Second Rule*, speak on this very subject. She gave these points to consider when a potential opportunity or stream of income presents itself:

- Does it advance my core business?

- How long will it take me to explore this opportunity?
- Does it deplete or energize me?
- Is there immediate publicity for my current projects?
- Are there relationships with long-term benefits?

By using these criteria, you will filter out anything that will drain your energy or dilute your core business. Be open to suggestions and feedback from other business owners. Try to set aside your preconceived notions about exactly how your business is going to grow and evolve. Sometimes we can be so overly attached to a particular customer, business deal, or activity that we are blinded to any other opportunities that present themselves.

The best streams of income are those that don't require a huge amount of time or effort on our part, or those that generate recurring income. I'm in the process of turning all of my live Money Wellness classes into online programs so I can guide more people to financial dignity. I do the work once, but my website can sell these programs over and over again with zero additional effort on my part. Writing a book is hard work! However, once it is finished, it can be marketed and sold thousands or millions of times over with no additional work required. You get the idea!

If you are a subject matter expert, you can write an e-book or record videos of your expertise to sell via a platform that specializes in delivering digital content to customers such as Zippy Courses, Teachable, Udemy, GumRoad, or Amazon Kindle. If no one in your field is doing this, even better because it sets you apart and makes you stand out. Imagine a tattoo artist who sells his video course on advanced techniques to other tattoo artists. He's probably not going to have much competition in that arena. The bonus is that he makes money every time someone downloads his videos.

Consider what part of your business drives the most dollars to the bottom line. It might not be the most obvious one. Looking

over the past year, my biggest paydays are the clients who purchase my six-month Financial Lifeguard on Duty coaching package. However, speaking engagements ultimately drive the most money to my bottom line overall, whether or not I get paid to speak. How can this be?

Speaking engagements typically place me in front of 25 to 50 people or more at one time. By standing in front of the room with a microphone, I have instant credibility as the expert. When setting up my speaking engagements, especially the free ones, I ensure I'm able to sell books to people after the presentation. I mention my coaching services to the audience during my presentation, in addition to capturing email addresses for my newsletter list. I almost always have someone from the audience contact me later, either for another speaking engagement, paid class, online course, or individual coaching. Speaking fills my sales funnel. I enjoy it, but honestly my favorite part of my business is the individual financial coaching. And speaking helps me gain more coaching clients.

CREATIVE MONEY EXPLORATION

Think about your own business and how you can add additional streams of income to support and enhance your core business and brand identity. Write down at least 5 to 10 either as a list or a mind-map. Don't filter yourself even if the ideas seem "out there" or downright ridiculous. If you're having trouble coming up with something, ask other creatives or business owners. Sometimes it's easier for us to see opportunities for others than it is for ourselves.

CHAPTER 17

Death by a Thousand Cuts

S mall, recurring business expenses don't seem like a big deal to the self-employed: $50 a month for video email service, $200 a month for social media management, $50 a month for an online customer management program, $400 a month for office space rental... These are all great tools for growing your business if you use them and you're getting a positive return on them.

However, I have coached entrepreneurs who have these seemingly small expenses add up to a collective cash hemorrhage every month. It's important to carefully evaluate those business expenses that recur monthly, quarterly, and annually to decide if you are *truly* receiving a good return for your dollars spent. Here are some factors to keep in mind when you consider adding or keeping a recurring business expense.

Frequency and Cost per Use. How often will you utilize this product or service? Daily? Several times a week? Only on occasion? Sometimes we think we'll use a product or service more often than we actually do. I am currently paying $49 a month for my email newsletter subscription service. I send three emails to my 1,500+ subscribers. I also use it to send follow up to the people who attend my classes. I typically send about 16 campaigns per month, which means my cost per use is $3.06 per newsletter. These campaigns usually bring me several coaching clients each month and drive sales via my website for online

classes and programs. If I gain only one coaching session from my newsletter each month, it's paid for itself many times over. On the flip side, about a year ago I realized that I was only using my video email service once or twice a month. And I was paying $50 per month for the service! (That's an expensive video email!) Because it really wasn't driving business my way, and therefore costing me money rather than making it for me, I canceled the service. There's no point paying for something you rarely use.

Buying Back Your Time. What is your time worth? Sometimes business owners keep doing certain tasks that could easily and inexpensively be outsourced or digitized. I learned this last year when I finally switched from QuickBooks' desktop version to Online. I used to update my accounting information once a week, by hand-entering all of my transitions into the program. This would take me about 30 minutes per week. It was tedious work even for someone who likes accounting. I finally bit the bullet and switched to QuickBooks Online, for a whopping $21 per month. QuickBooks automatically syncs with my business bank account, so I don't have to enter all the transactions. All I need to do is verify the items are categorized properly and approve them with the click of the mouse. What used to take me two hours a month now takes me less than 30 minutes, plus I'm able to see how my business is doing in real-time, not just once per week. Buying back 90 minutes of my time for only $21 is a great deal since I can use that time for a coaching session and charge almost 20 times that amount. So, figure out how much time you spend on both business and personal tasks and see how much of it you can buy back for yourself to spend on the activities that *make* you money. I once heard it said, "If you ever hope to be a millionaire, you won't clean your own toilet or mow your own grass." You've got better things to do!

Shared Services. If there is a product or service you need for your business, consider sharing the expense with someone else. You could do this with office or production equipment, clerical help, even office space. Unfortunately, I see business owners lock themselves into contracts for products and services

that no longer meet their needs and are a drag on their bottom line.

How do you determine whether or not you should add new recurring business expenses to your monthly budget? Be sure to occasionally look at the overhead you currently have and decide if each expense is still paying you dividends in saved time or earned sales. Don't let these seemingly small expenses deliver death by a thousand cuts to your business cash flow!

CREATIVE MONEY EXPLORATION

Examine your recurring business expenses and ensure they are benefiting you. What, if anything, needs to go?

CHAPTER 18

The Mystery of Pricing & Value

Figuring out how to price your products and services is about as clear-cut as how to hunt for unicorns. I find that many creative entrepreneurs struggle with this.

"How do you put a price on your art?" asks Heather Rae Hutzel, Christian author of multiple books, including the upcoming young adult fantasy series *ANOINTED*. "I 'labor' over my books. They're 'birthed' out of a part of me. How do you put a price on your 'baby?' Determination of price doesn't just feel like a valuation of your product, but of your personal value too. It feels like people are judging your art *and* you when they put a price on it," she says.

And Heather's not alone in this line of thinking. Many creative entrepreneurs vacillate between feeling like their art is priceless to almost giving it away when a potential customer is willing to pay full price. Some artists refuse to take money for their art because they think selling it makes them a sellout. Just because you love to do something and it's easy for you, doesn't mean you shouldn't get paid for it. In fact, the opposite is true. An airplane pilot (who had better love to fly) would never think, "Ugh, I can't believe I'm whoring myself out to this commercial airline!" Instead they're likely thinking, "Holy crap! I can't believe I'm getting paid to do what I love!"

We need to come to the place where we recognize that it's more than okay to be paid for our creative work, because it adds

real value to the people buying it. Just be aware that determining the value of your offerings is not an exact science. Fortunately, there are some guidelines to help you.

What are your competitors charging? Shopping the competition is a great place to start. If you're a massage therapist, it's easy to discover what others are charging for a 1-hour treatment. You'll likely find a price range that's affected by a myriad of factors: experience of the massage therapist, environment where the massage occurs (Spa vs. Strip mall vs. In-home), and extras like the use of organic essential oils or hot stones. Analyzing these factors will help you narrow down the range for your own services. If you're a newly minted massage therapist with an office in a suburban shopping center, you're not going to be able to command as much for a 1-hour massage as someone in a high-end spa environment with a decade of experience and a loyal clientele.

What is your cost of goods sold? Obviously, you need to take into account the actual cost of your product or service in the pricing. If you're not adequately covering your costs, you have a charity, not a business! You have two types of costs to cover: direct costs and indirect costs (also referred to as "overhead"). Direct costs are those directly involved in the production and delivery of your product or service. For our massage therapist example, there's really only her time and the massage oils or lotion that are direct costs. However, she's got a variety of indirect costs: rent for her office, utilities, advertising, marketing, etc. You absolutely must cover your direct costs with each and every product or service you offer. And you'll need to sell enough of them to cover your overhead.

What is the value to your consumers? As Drew Schwegman, ActionCOACH, says, "Charge for the value you bring to the hour, not for the hour." What does he mean by that? Some of you might be shocked if you heard of a business coach who charges $2,000 for a 1-hour session. But what if that coach gave the business owner advice that makes him an extra $10,000 within 30 days? Most business owners would trade $2,000 for advice with a $10,000 return all day long. So, don't just give yourself an arbitrary hourly rate for your services, but really

consider the tangible value your customers walk away with after they meet with you. There must be a value for your time, resources, and artistic vision.

Who is your ideal customer? Is it people with physically demanding jobs who need a massage to relieve pain, or ladies who want a luxurious pampering session? Your pricing should reflect the financial resources of your target market. When I realized that my ideal coaching clients were high-income professionals and small business owners, I adjusted my pricing to reflect that. Yes, that means I am too expensive for some people who want to work with me, but they don't fall into the bullseye of my target market. And that's okay!

Pricing is something you'll need to revisit as your business changes. If you move to a new and nicer location, it might be time to increase your rates. If you complete a major certification or have racked up other credentials, you'll want to adjust your prices to reflect your higher value. Do a gut check—do your new prices both scare and excite you? Ask other business owners or past customers for their opinions about your pricing. You might be surprised that your customers would willingly pay more for your products or services and still feel like they're receiving a good deal.

Once you set your prices, own them! Don't be shy about discussing your pricing or apologize for your rates. If you're not confident in your prices, your potential customers will pick up on that. Molly Gray, owner of Tantrum Content, discusses her pricing and payment terms early on in her conversations with potential clients. "It's better to get it out in the open at the beginning instead of putting off the money discussion. It's okay and necessary to talk about money. It's okay to define the worth of your work," says Molly.

I've been asked by my entrepreneurial clients if they should publish their prices (maybe they don't want the competition to know) or wait for the customer to inquire before revealing pricing. If you have a standard product of service, it's my opinion you should be up front and publish it on your website. I'm transparent with the prices of my coaching packages and various online courses and include them on my marketing materials and

website. This also serves as a screening tool for those who can't afford your product or service. It's best for the potential customer (and you) to find out immediately versus after a 30-minute meeting or 1-hour phone call.

If what you do is more custom, or you have certain services with multiple variables which dictate your price, it's best to fact-find first before quoting a price. I do this with my speaking engagements, because the price will vary based on the length and number of times I'm speaking at an event, if travel time is involved, and whether it's a custom presentation or one of my "standard" money wellness talks. I usually ask the potential customer to tell me exactly what they want and ask what their budget is for the project. Sometimes, they will tell me a number that's more money than I expected! This is a wonderful situation because you can assure them that your quote will come in under their budget. In that case, I will come in 10% or so less than the client's budget and seem like a hero, while still receiving more money than I might have charged if I hadn't asked the question, "What's your budget?"

Bonus tip on pricing: If you visit my website, you'll notice that all of my prices end in 7. Why? For whatever reason, people love the lucky number 7. Plus, when you end a price with a zero, it seems like it's negotiable, like it's an estimate. But when you end with a 7 it's an odd number and it appears as though you put a lot of thought into your pricing. So, rather than charging $100/hour for one of your services, try changing it to $107/hour and see if you don't sell more because of it. This little trick worked for me! Tag me on social media and let me know if it works for you.

CREATIVE MONEY EXPLORATION

Examine your current pricing. Does it reflect the level of value that you're bringing to your customers? If not, adjust it!

Do you feel nervous (and a little excited) about your new pricing? Rehearse pricing discussions with yourself in the mirror or with a trusted friend until you own your new prices.

Try ending your prices with a 7 and see if it causes an increase in your sales.

CHAPTER 19

Discounts & Trade Deals

When is it wise to trade products or services with others? What are the pros and cons of doing this? How can you ensure it's a positive arrangement for all involved?

Entrepreneurs may decide to enter into "trade deals," bartering with each other for certain products or services. The obvious benefit of this arrangement is that no cash changes hands. (Please consult with your tax professional regarding the potential tax consequences of bartering.) However, trade deals have the potential to go awry if they aren't set up properly at the onset.

Here's a warning of what can potentially transpire if a bartering arrangement isn't clear and specific at the onset. Early in her career, when funds were tight, photographer Triston D. traded family photo sessions with her hair stylist of 10+ years. The woman just welcomed a new baby to her family, and Triston thought it would be a wonderful idea to barter photography sessions for her quarterly cut and color. For the first few months, the arrangement seemed to be going well. However, as time passed, Triston noticed that the quality of her cut and color sessions that were done in trade were NOT the same high quality she received when she was paying cash. The relationship became weird and strained, eventually Triston sought out a new stylist. (And I probably don't have to tell you how traumatic it is to switch hair stylists or barbers!)

Could this mishap have been avoided? I believe, with clear communication, trade deals can be a positive arrangement. Be upfront with how the details of the trade are going to work before you start. Are you going to trade session for session? Are you going to give the same dollar amount of product or service to each other? No, you don't necessarily have to sign a formal contract, however, I advise getting all the details in writing via email. Make sure the deal is equitable and everyone is agreeable to the terms.

Do one trade deal at a time; don't allow it to be open ended. Your pricing structure may change, which would throw off the balance of the bartering deal. Keep lines of communication open. Triston hasn't given up on trade deals altogether because of one bad experience. In fact, she currently trades business photography with her CPA and her attorney, now adhering to the guidelines I just mentioned.

One con to consider with trade deals is that you are conditioning the person to *not pay* you for your products or services. Ideally, both parties should feel like they're getting the better end of the bargain. If it starts to get weird, have a conversation. Square up with each other, then move on to a pay-for-services arrangement. Don't enter into trade deals lightly. If things go sideways, you could burn a bridge and lose a valuable business contact, friend, or hair stylist!

What about discounting your products or services? Should you do it? If so, under what circumstances? First of all, you must understand your cost of doing business so you don't discount too deeply and lose money. It's important to know what your break-even points are on your products and services, one which considers both your direct costs and your overhead. (See chapter 12.)

I rarely discount my coaching services, and if I do, it's not by much because my time is valuable. It's more palatable for me to discount my digital products—online programs, webinars, e-books—because once those products are created, there's almost zero direct cost for additional units sold. In fact, when potential clients inquire about discounts for coaching, I'm usually firm on the price, but I may throw in a free online program or webinar

as a bonus. Those digital products are valuable in the eyes of clients, but it doesn't cost me anything to give one away. I'll use these digital freebies as closing tools for my coaching packages.

I am a fan of volume discounts if they make financial sense for your business. For example, if an employer wants to put 50 people through one of my online classes but is balking at the full retail price, I would happily offer them a discount. The company is bringing me 50 new customers who will now be on my email list. The online class is going to happen with or without this employer's participation, so it makes sense to lower the price of admission to gain these new students. I'll receive a cash infusion directly from the company, plus I'll be up-selling the online class participants on coaching, books, and additional online classes.

Another example of volume discounts I will give is for direct book sales. If an organization, employer, or financial planner wants to purchase a large quantity of books for their employees, members, or clients, I'm more than willing to give them a discount based on the volume. Why? I have a good profit margin on books I sell directly to customers, which means I have room to negotiate and still make a nice profit. Plus, once these folks read my book, there's a good chance that they'll follow me on social media, visit my website, or purchase another product or service from me in the future. In both cases, I'm receiving exposure to a larger group of potential future customers in one fell swoop, which saves me both time and marketing dollars.

As you consider your products and services, would it make sense to offer volume discounts or freebies? If so, under what circumstances? You should feel like there's an upside or benefit in return for the offer. If not, discounting may not be for your creative business and that's perfectly okay.

What should you do when your family or friends inquire about, or perhaps even demand, that you extend them a discount or freebie? This is a common complaint among the self-employed. Those closest to them don't value their creative work or expect a "friends and family" discount. Certainly, you can give a discount if you'd like to; just ensure you'll still be making a decent profit margin or you'll end up harboring resentment towards the recipient.

Fellow author and entrepreneur, Jon Acuff, offers a brilliant response to the loved one who's trying to extract a freebie from you in his blog post, "Saying No to Friends Who Want You to Work for Free." (The link to read this blog post is included in the Recommended Resources in the back of this book.)

Here's his two-step approach:

The first thing you say when someone asks you to do some work for free is, "What's your budget?" If they have a budget, and you want to do the work for your friend, then go for it. But what if they say they don't have any money to pay you?

Jon says to follow up with this: "In order to honor and fulfill the commitment I've made to my paying clients, I can't take on any pro bono right now. I love doing it when I can, but I don't have the time." Brilliant, right? I've used this exact wording to turn down people who would like me to coach or speak for free and it works like a charm. He ends the blog post with this gem: "Care about your craft enough to charge for it." Well said, Jon Acuff. Well said, indeed!

CREATIVE MONEY EXPLORATION

Are you willing to offer discounts or enter into trade deals? If so, under what circumstances? Have you ever had a "friends and family" discount or trade deal go bad? If so, what happened and how did it make you feel?

CHAPTER 20

Turn on the Cash Flow

C ash is the lifeblood of a small business, and yet I am shocked by how few business owners actively forecast and manage their cash flow! You could blame the economy and market conditions for erratic and spotty sales, but the truth is you have more control over your income and sales than you think. And that is great news!

The first step to turning on your cash flow is to actively manage your potential leads in your pipeline. If you don't have a formal system for tracking and following up on your referrals and leads, you are letting dollars slip through your fingers. You don't need a $1,000-lead tracking software to do this either. Spreadsheets are free and inexpensive web-based customer relationship management (CRM) programs like Pipedrive are effective and super easy to use.

Once you have your leads on paper or in a CRM, it is much easier to forecast your potential cash flow. Look three to six months out into the future. What billable hours or projects have you already booked that you can count on to invoice? What leads are likely to close or convert in that time frame? How much potential income does that represent to you? The key to gushing cash flow is a full pipeline of potential customers.

How full is your calendar? Sales guru, Grant Cardone, says, "White space on the calendar is the devil!" A little extreme? Maybe, but blank space on your calendar means fewer dollars in

your pocket. What should you do if there is blank space on your calendar for which you can't bill a potential customer? It's time to sow some "investment hours."

Investment hours are spent going to networking events, meeting with potential customers or referral sources, doing speaking engagements, and yes, even making cold calls and drop-by visits. By scheduling these activities on your calendar when you're not actively billing or engaged in creative production, you are planting seeds for a future harvest. Don't forget to track and follow up with the opportunities that will surely come from these "investment hours." Doing so will ensure that the flow in your pipeline is gushing like a fire hose!

CREATIVE MONEY EXPLORATION

Look at your calendar over the next two to three weeks. While leaving room for your creative production, fill in some of that white space with sales and networking activities to sow seeds for future projects.

CHAPTER 21

Collecting with Class

In college, I worked in collections for a major credit card issuer. It definitely wasn't a fun job, but it paid the bills and offered 80% tuition reimbursement. Shortly after graduation, I started my career in corporate accounting where I spent 15 years. One of my responsibilities was collecting on delinquent customer accounts, so I have extensive experience in both personal and business collections. I know what works and what doesn't when it comes to getting your customers to pay what they owe you.

In my opinion, it's better to hop on the phone *first* rather than send an email regarding payment collection. Email is going to feel like the easy way out, but you have to trust me on this. It's much easier for your customer to ignore an email or claim it got lost in the shuffle, than to ignore a live person on the phone or even a voice mail message. Because the phone is more personal, people are less likely to become angry or defensive than they would via email. Plus, your voice conveys warmth and positivity that a written email can't express.

Here's what to say: "Hello John! It's Christine over at XYZ Company. I'm calling today to see what date you paid our invoice #123, as we haven't received payment yet, and I wanted to make sure it didn't get lost in the mail."

Note that I'm assuming the best, rather than the worst. I also didn't ask "did you pay it," but rather "what date did you pay it."

If they say that, "Yes, the check has been cut," ask when it was mailed. This will give you a reasonable time frame to follow up if you don't have it within another few days. Checks really do get lost in the mail! It happened to me just a few months ago with a client who always pays me quickly. They were happy to void the original check and reissue a new one to me.

If they say the check hasn't been cut yet, I would follow up with this, "Okay, what day will the payment be made?" You could also say, "I'd be happy to take a credit card over the phone so we can take care of this today, plus you can earn some cash back or travel miles!"

You are still assuming the best, that they want to pay you and make good on their invoice. You're also giving them a way to solve the issue immediately. No one wants to be on the receiving end of a collections call, so the more pleasant you are, the better.

If the person doesn't commit to a payment, ask, "Is this purely a cash flow issue?" Sometimes, there is an issue with the invoice not having the correct purchase order or the proper person's approval. Or, there may be an issue with your product or service that is the reason for the non-payment. Until you figure this out, you won't be able to address it.

If it's simply a cash flow issue for your customer, see if you can work out payment arrangements. Say, "I understand you're not able to send the full amount at this time. How much can you pay this week?" You may find out that they can pay half this month and half next month via credit card, and you can set up the payments while you're on the phone with them.

If someone wouldn't commit to a payment at the manufacturing company I used to work for, we would say, "It's my company's policy to report any accounts over 60 days to Dun & Bradstreet. Can you at least commit to sending a partial payment today, so I can prevent that from happening?" When accounts got past 60 days, we would refer them to Dun & Bradstreet to collect on them. Small businesses can also hire an attorney to do this for them, but I don't suggest doing that until you've made several attempts for payment.

Whatever transpires in the phone call, I follow up with an email to confirm the conversation in writing. For example, "Nice talking to you today, John. Just to confirm, you will be sending your payment of $5,000 for invoice #123 on 4/15/xx. Thanks again for your help!"

COLLECTION PREVENTION TIPS

The best offense against collections is a good defense, so follow these tips to prevent collections from happening in the first place.

- Collect a down payment—or payment in full—with the order. This may weed out financially strapped customers right out of the gate.
- Offer a discount for payment in full up front.
- Build in progress payments for larger projects. You might have one-third due as a down payment, another third due halfway through the project, and the final third due after project completion. Be creative!
- Offer a monthly payment plan to automatically bill their credit or debit card. PayPal and other payment providers make this easy for you to do.
- Make it convenient and easy for customers to pay you. The more payment options you provide, the better. I accept cash, check, PayPal, debit and credit cards (via Square). Yes, some of these do charge a small fee, but it's better to have 96% of your money in hand than 0%.
- Consider a membership to Dun & Bradstreet if a large portion of your clients are corporations. D&B allows you to run corporate credit checks, so you know the company's payment history and they even suggest a maximum credit line.

CREATIVE MONEY EXPLORATION

Which of the collection prevention tips will you incorporate in your business starting now? Who owes your company money? Using the script in this chapter, grab your phone and make the collection call with class.

CHAPTER 22

Partners & Investors: A Cautionary Tale

I f your business is suffering a cash crunch, landing an investor or taking on a partner may *seem* like the golden ticket to easy street. I've seen entrepreneurs in the startup phase work harder on trying to attract a financial backer to their business than they're actually working on the business itself. Certainly, there are benefits to having partners and investors. You'll have more cash to launch or expand your business. You'll have built-in support and accountability on your entrepreneurial journey. Attracting partners and investors gives your business validation and legitimacy.

Partnerships are a relationship of equals or peers, and sometimes these arrangements work very well. I witnessed this first-hand at my family's business, KRC Machine Tool Services, where I worked as the VP of HR and Accounting for thirteen years before starting my own business. My Dad started the business in 1989 with four other partners, and four of the five original owners are currently still active in the company. Here's what he did right when forming the business: his attorney drew up a formal partnership agreement. It clearly stated expectations, rules for voting on major issues facing the company, and a process to buy out owners who may want to exit the business in

the future. Unfortunately, not all partnerships have a fairytale ending.

I recently interviewed an entrepreneur who had to legally remove her partner from the business for using company funds to pay for his personal expenses. She managed the sales and marketing for the business and he handled accounting and IT. In retrospect, she says she should have insisted to see more of the monthly accounting details, but that's not her strong suit. She trusted her partner to take care of it and he betrayed her. This story is all too common among business owners, which is why you need to exercise caution when deciding whether to take on a partner in your business.

Even if you have a fantastic business partner, you still need to have a formal partnership agreement. What happens if one of you dies? Does the remaining partner retain the right to buy their ownership share? If not, you may find yourself co-owners of a business with your former partner's spouse or grown children who know nothing about your industry. What happens if one partner becomes disabled and can no longer work in the business? What if one of you wants out? No one likes to think about these things when starting a partnership, but it is crucial to the success of the company that you hire a lawyer to draw up a solid partnership agreement.

An alternative to taking on a partner is finding an investor for your business. What's the difference? Usually, partners both invest capital and work hands-on in the business. Investors typically provide operating cash but don't work in the business from day-to-day. However, investors and their big pots of money aren't a panacea to fix everything that ails your creative business. When you accept their money, you now have to answer to the investor. Because they hold the purse strings, *they are now the boss of you*. If you started your entrepreneurial adventure because you didn't want a boss, you'd better think long and hard about accepting an investor's money.

You also lose some of the control over the creative direction of your business when you take on an investor. If the investor doesn't buy into your new idea to expand your product line, the idea may be killed while it's still in the embryonic stage.

If you are going to take on an investor or a partner, make sure you do the following to protect yourself and increase the likelihood of success of the venture:

Thoroughly research your potential partner or investor, even if you already know them. Interview former coworkers, bosses, and subordinates who have worked closely with them. Talk with other entrepreneurs who accepted the investor's money and find out how the arrangements are working out. I'd also advise a criminal background check and credit check for all parties involved. As long as there's nothing to hide, no one should object to this.

Use a mutually agreed upon attorney to draw up the partnership or investor agreement. If your partner's or investor's lawyer is drafting the agreement, have your own attorney look it over to ensure it's a fair deal for you. Trust me; it's worth paying someone a few hundred dollars to ensure you're not making a mistake that could cost you and your business thousands down the road. Either way, getting a second set of eyes on the contract before you sign is a wise idea.

Include an exit provision. You want to ensure you can buy back the ownership of your investor or business partner in the future if you choose to do so. You may also want to exit the business yourself, so there needs to be a provision for you to sell your ownership as well.

If there's a non-compete clause in the contract either with a partner or investor, ensure it is reasonable and fair. A non-compete prevents either party from exiting the arrangement and going into direct competition with the other person, usually for a set period of years. I heard about a woman embroiled in a court battle over a non-compete dispute when she exited the company she founded. She disagreed with her investors regarding the direction of the business so she left. Last I heard, she was unable to make a living with her expertise, because she'd be directly competing with her former company. She would either have to go to work for a non-competing company or start another business in a different line of work. It's definitely worth having your attorney look it over so you know the consequences of what you're signing.

CREATIVE MONEY EXPLORATION

Would you be willing to take on a partner or investor if the opportunity presented itself? Under what circumstances would it be agreeable and profitable for you? Commit to having the proper legal protections in place if you decide to go down this road.

CHAPTER 23

Business Debt

I s it possible to operate a business 100% debt free? For some businesses the answer is definitely yes; and for others probably not. If you're a creative entrepreneur who doesn't require capital for equipment purchases or a large facility for your business activities, you can and should operate your business debt free. Why? Borrowed money magnifies risk. People are more willing to take chances with the bank's money than they are with their own cash.

Let's look at the three types of business debt: The Good, the Bad, and the Ugly. My definition of "Good" business debt is a loan for a cash-producing asset. Some examples of this are investing in your website to upgrade the look and function to deliver on-demand digital programs, loans for cash-producing production equipment, or lines of credit to cash flow profitable jobs.

Joe, a professional narrator and voice over artist, is considering purchasing equipment to convert a room in his house to a recording studio. Joe currently rents time at a sound studio when he books a radio commercial or audio book project. He figures he's easily paying $5,000 - $7,000 per year to the owner of the sound studio. If Joe invested that same money into his own studio, after the first year he would be saving that $5,000 each and every year. Plus, he'd be able to take on additional

projects and execute them on his own schedule, rather than working around the time slots available with the rented studio.

"Bad" business debt is borrowing money on items that do not generate a profit for the business. This can include loans for non-cash producing items like vehicles and furniture, lines of credit to cash flow non-profitable jobs, and failing to pay off business credit cards monthly. This type of business debt is costing you money, rather than making you money. Steer clear of it, if at all possible, to keep your business financially healthy.

"Ugly" business debt is reckless and downright dangerous. This type of borrowing costs you big time and can put your business finances in critical condition. Examples include: borrowing money to make payroll and "keep the business alive," and using personal debt to fund your daily business activities. If you are in this type of situation, you need the assistance of a CPA, business coach, or a financial coach to determine if your business is viable. Don't put your personal financial wellbeing at risk trying to save your sinking ship of a business.

Both personal and business debt can be like a cancer that spreads and destroys your financial health. My best advice about business debt is to avoid it if you can. Be very cautious and conservative with any debt you take on, even if it is for cash-producing assets.

CREATIVE MONEY EXPLORATION

Write down the amount and sources of debt you have for your business. Which category does each fall into: the good, the bad, or the ugly? Make a plan to pay off your "bad" and "ugly" debt with a portion of your monthly profits ASAP!

CHAPTER 24

How Much Should I Pay Myself?

When talking with my self-employed clients and friends, the question always comes up: "How much should I pay myself out of my business?" Followed closely by, "How much should I set aside for taxes?" and "How much should I invest back into my business?"

The answer to all of these questions is: "It depends!" Yes, it would be nice if I could just give a cookie cutter answer like, "Pay yourself 60% of your profits, invest 10% back into your business, and save 30% for your estimated tax payments." Unfortunately, there are a myriad of factors that affect the answer, so we can't end the chapter right here. Depending on the complexity of your business and tax situation, you'll likely need the assistance of your tax or accounting professional to determine the exact numbers. Let's look at a few of the things to keep in mind with question #1: "How much should I pay myself?"

In the start-up phase of your business, you may be paying yourself less—sometimes much less—than your former day-job paycheck. This might be necessary to successfully launch your creative business, but it shouldn't continue this way once you're consistently profitable. And the point needs to be made that if your business is NOT profitable, you're not going to be able to pay yourself. This is why it's vitally important to manage your money like a boss!

During the research phase of this book, I interviewed over a dozen business and creative coaches. The vast majority of them agreed that creative entrepreneurs undervalue their contribution in the business and thus underpay themselves. To refine the amount you should be paying yourself, there are additional questions to ponder.

What do creatives with similar responsibilities and skills earn working for someone else? If you're a self-employed graphic artist who used to work in Corporate America, you may already know the answer. If you have zero clue, do a quick internet search for average salary ranges for your field and location. You can ask other, more well-established self-employed creatives what they pay themselves, but be prepared to get the cold shoulder, especially if they view you as competition. People would rather talk about their sex lives than the details of their finances, especially their income. You might have better luck in an online forum connecting with others doing similar work in another part of the country who don't see you as competition.

What roles am I taking on in my business, besides the creative production? Most entrepreneurs spend time on sales, marketing, business development, and clerical tasks. Don't just pay yourself for the hours worked on creative projects. For example, let's say that last week you spent 16 hours on location shooting photos for paying customers. You spent an additional 16 hours working your editing magic on those photos. You spent four hours communicating with customers and potential clients in person, via phone, and via email. Finally, you spent four hours invoicing, filing, paying bills, and sending your weekly newsletter out to your email list. That adds up to 40 hours. Although you might argue that you were only working 32 hours on billable projects, the truth is that the other tasks are necessary for obtaining paying customers and running your business. You should pay yourself fairly based on the total amount of hours worked.

How much do I need to pay my personal bills? If you're not paying yourself enough to cover your personal bills at home, that's a problem! This is why the first step to managing your

money like a boss is getting your personal finances in order. If you haven't done that yet, put this book down, and go read or listen to my book, *Money is Emotional*: *Prevent Your Heart from Hijacking Your Wallet*. Once you have your personal spending plan, you'll know the minimum you need to pay yourself to cover your personal bills. If you're married, or otherwise attached, your spouse or partner will appreciate you paying yourself a regular, set amount, so there are no unpleasant surprises in the personal budget.

You can decide whether it makes sense to pay yourself weekly, bi-weekly, or monthly. Whether this is done via a payroll check or an owner's distribution of profits will depend on your business tax structure, so consult with your CPA on the proper way to pay yourself. Your amounts may vary based on the profitability of your company. However, you should distribute a minimum amount unless you're in the red.

CREATIVE MONEY EXPLORATION

Answer these three questions:

- What roles am I taking on in my business, besides the creative production?
- How much do I need to pay my personal bills?
- What do creatives with similar responsibilities and skills earn working for someone else?

Based on your answers, determine how much you should be paying yourself in your business. If you're not making enough in your business to do that yet, take heart! We're going to be delving into a myriad of ways to increase your sales and income in the coming chapters.

Chapter 25

How Much Should I Invest in My Business?

It's a wise move to earmark a percentage of your business profits to reinvest in growth and expansion. These investments may be as diverse as production equipment for a micro-brewery, a new tattoo gun, a mobile-responsive website with online shopping cart, or hiring a sales coach. The exact percentage will vary depending on both the type of business and its profitability.

The amount you invest back into your business will be constrained by your estimated tax payments and how much you pay yourself. It may also fluctuate year to year based on your business activities. For example, I invested a much larger percentage of profit into my business during 2016-2017 with the publication of my first book. Even though I self-published, I didn't want that fact to be obvious to my readers. I invested in professional cover design, interior layout, editing, and a professional narrator for my audio book. I also hired a speaking coach, because I knew I'd be booking more speaking engagements as a result of the book.

My point is—you will have seasons when you'll be investing more in your business because of a growth spurt or product launch—so you may choose to pay yourself less for a period of time (not indefinitely). *Just don't underpay your estimated tax*

payments; always pay Uncle Sam first. (See chapter 26.) If I look back over the history of my business, I see that I usually invest at least 10 - 15% of my profit back into business growth and development.

What's the difference between an investment in your business and a run-of-the-mill expense? An investment is an expenditure that will enhance the long-term profitability and cash flow of your creative business. A good investment will produce a return many times over the initial cash layout. When I invested in the publication of my book, the one-time cost provided me with a quality product which continues to generate cash flow indefinitely, via book sales and speaking opportunities. In fact, I recouped my investment some time ago, so future royalties and speaker fees are now pure gravy!

Here's another example: TJ Bitter of Tandem Productions started his videography business several years ago. He shot weddings on evenings and weekends, yet still required a side job at a restaurant to pay the bills. Glenn Warner, a business coach and the founder of GorillaMaker 3-D printers, took on TJ as his mentee and taught him the value of investment. Glenn suspected drone videography would have a positive and profound financial impact on TJ's business, and advised him to invest in the equipment. At first TJ balked at the price, but Glenn showed him how quickly he could recoup his cost and start making profit with the drone. TJ realized the potential beyond weddings to corporate videos, using the drone to showcase a business location from an aerial perspective.

CREATIVE MONEY EXPLORATION

Consult with your accountant or CPA to determine a good target amount for your business investments. As you look out over the next year, what equipment, training, software, coaching, and other creative tools will increase your profitability and cash flow the most?

CHAPTER 26

How Much Should I Save for Taxes?

According to Alan R. Clopine, CPA, and co-host of *Your Money Your Wealth* radio show, a common mistake he sees small business owners make is failing to pay estimated tax payments. This sets into motion a vicious cycle of always playing catch up. You end up paying last year's taxes with this year's profits. The only way to break this pattern is to pay your estimated tax payments quarterly with current year profits.

So, how much should you save for taxes? Make an appointment with your CPA or accountant. Seriously. I got a D in my Tax Class in college, so the only tax advice you should take from me is this: *seek the help of a professional and pay your estimated tax payments as he or she prescribes.* That is all.

CREATIVE MONEY EXPLORATION
Make an appointment with your CPA or tax professional to determine the amount you should be saving for your estimated tax payments. I highly recommend opening a separate checking or savings account to house this money until it's due to be sent to the IRS.

CHAPTER 27

Taking Care of Elder You

U nlike someone who's traditionally employed, you don't have a pension or company-provided 401(k). This means you are the boss of your retirement planning! Unfortunately, quite a few entrepreneurs neglect this until it's too late. There are a variety of excuses we use to put off dealing with retirement planning: "I don't have any extra money to set aside right now. I'll wait until my business gets off the ground and has a really great year." "Investments are confusing. Besides, I'll get a little something from Social Security." "My spouse is contributing to his/her 401(k), so we should be okay." "I love my work! I don't ever plan on retiring!"

Here's the thing: it's your duty to take care of "elder you," and you need to start right now. It's hard for us to have urgency for something which seems so far in the future. However, the years fly by fast and next thing you know, you're 55 years old with only $5,000 in your retirement account. This is why I ask my coaching clients to hang a digitally-aged picture of themselves on their financial vision board as a way to remind them that they're responsible for caring for their elder self NOW.

There are websites that will age a picture of "current you" so you can see what you'll look like in your golden years. You might find it a little unnerving to see your elderly self, but that's the point. As you look at "future you," I hope you'll have some compassion and want to take care of him or her as you would

your elderly parent or grandparent. Think of how you want life to be like for elder you. Do you want to be painting seascapes on the beach in south Florida or stuck in a government-funded retirement home?

Alan R. Clopine, CEO of Pure Financial Advisors, has this advice for small business owners: "Try to start your retirement savings in your first year of business! Get in the habit of paying yourself first. Don't wait until you can 'afford' it or wait until you 'have a great year.' Open a solo 401(k) or IRA and have money deposited automatically every month." This establishes the savings habit, and you can adjust the amounts up as your business prospers.

Even before you decide what type of retirement account is best for you as a creative entrepreneur, you need to select a financial planner if you don't have one already. Yes, I know this process can be nerve-racking, but it's vital to your financial wellbeing. I advise choosing an advisor who is a fee-only fiduciary and also preferably a Certified Financial Planner. Here's what that means. Someone who works on a "fee-only" basis charges you a flat fee, or a small percentage of your assets, per year. The advisor doesn't receive commissions based on the types or brands of investments that he or she sells you. So, your financial planner is incentivized to grow your overall balance based on what is best for you and your goals, not what is going to pay them the most commission!

When your advisor has the Certified Financial Planner (CFP®) designation, he or she has undertaken a thorough study of all areas of investing, personal finance, tax, and insurance. A CFP looks at your financial picture holistically to see how all the various parts affect each other. Ask friends and family for referrals, then meet with at least two or three advisors before making your pick. Select the advisor who listens to you, answers your questions, and makes you excited about your financial future!

I interviewed Darren Wurz, an independent fiduciary and CFP, and he gave me the following overview of the options available for retirement accounts to share with you.

TRADITIONAL IRA

IRA, also known as an Individual Retirement Account, which means it's a plan for individuals only. Contributions you make to a "traditional" retirement account are tax-deductible, which reduce the amount of tax you owe in the tax year you contribute. However, you will owe tax on the money when you withdraw it for retirement. Also, taking withdrawals before age 59 1/2 triggers income tax, plus a 10 percent early withdrawal penalty. The maximum contribution for 2018 is $5,500.

ROTH IRA

A Roth IRA is subject to the same rules that apply to a traditional IRA, except when it comes to taxes. Contributions to a Roth IRA are taxed up front, but withdrawals made during retirement are completely tax-free. This means your earnings grow tax free in the account. As the saying goes, "It's better to pay tax on the seed than on the harvest!" Additionally, you can withdraw original contributions (but not earnings) under certain circumstances before retirement without triggering tax or a 10 percent early withdrawal penalty. The maximum contribution for 2018 is $5,500. You don't have to be self-employed to invest in either a traditional or Roth IRA account, but they have income limitations, so if you make too much money you might not qualify.

SEP-IRA

An SEP-IRA, or Simplified Employee Pension IRA, is simple to administer and has a higher annual contribution limit than traditional or Roth IRAs. You make contributions for yourself and your employees if you have any. You must be self-employed to be eligible for this type of retirement account. It doesn't matter whether you're set up as a sole proprietor, a partnership, or a corporation. A nice benefit of the SEP is that you can make contributions in years when business is good and skip them if money is tight. The one potential downside is if you do have employees, you must contribute an equal percentage of income to their accounts as you do to your own. And if you withdraw funds from your SEP-IRA before age 59 1/2, you're subject to

income tax, plus an additional 10 percent early withdrawal penalty. You can contribute 25% of your earnings up to $55,000 per year.

SAVINGS INCENTIVE MATCH PLAN FOR EMPLOYEES (SIMPLE IRA)

The SIMPLE IRA has a maximum contribution for 2018 of $12,500. In addition to your contributions, you can elect to have your business match a percentage as well. If you have employees, the business is required to contribute 2% of your employees' salary or match 3% of their contributions. So, if you have a lot of employees, be aware of the matching costs.

INDIVIDUAL 401(K)

This is sometimes called a solo 401(k) or a self-employed 401(k), which allows you to contribute up to $55,000 a year. You can make Roth or pre-tax contributions. Just like a company 401(k), you can take loans against your balance. 401(k) are more flexible when you have employees than SEPs or SIMPLEs and can be designed to meet the needs of your business. However, there are costs associated with maintenance of the plan for IRS compliance.

Disclaimer: I am not an investment advisor and am not advocating any type of retirement account or investment vehicle. This is for informational purposes only to motivate you to save for the future and inform you of the importance of seeking guidance from a qualified advisor. IRS guidelines governing rules regarding contributions and early withdrawals are subject to change, so please visit IRS.gov for the most current information.

CREATIVE MONEY EXPLORATION

If you don't already have an investment advisor, interview at least two of them. Select one and set up a retirement account. Begin depositing at least a small amount monthly into it.

CHAPTER 28

Financial Risk Taking

If you're a risk-adverse entrepreneur, it's likely you'll have ulcers and empty pockets before too long. Taking smart, calculated risks is woven into the fabric of the entrepreneurial life. When it comes to managing your money within your business, where is the fine line between the calculated financial risk and the reckless one? If you're petrified to spend money to invest in your creative business, that's just as detrimental as taking out a bank loan with no solid plan for how you'll earn the money to pay it back.

If you have a genius idea for adding a new service product line to your business offerings but would need to borrow money to get it started, is that a calculated risk or a reckless one?

If you strongly feel you need to hire a business coach to take you to the next level but would be dipping into your savings to pay her, is that a calculated risk or a reckless one?

Your business is bleeding cash fast, so you decide to take on a partner or investor. Is that a calculated risk or a reckless one?

Here are several things to consider when you're pondering a big financial decision in your business:

Will taking this financial risk light a fire under me to rise to the occasion? Sometimes, we need to go "all in" to motivate ourselves to take actions that are outside our comfort zone. For example, I recently quit a client for whom I was doing bookkeeping work. I'm a Financial Lifeguard; my core business

is coaching, teaching, and writing. Bookkeeping is not any of those things, and it's not my favorite thing to do. Why did I bother with it? The job paid me about $2,000 per month; it was a security blanket for me. However, it was also occupying 25% of my available productive time which could be spent on more meaningful work. Giving up that customer was a calculated risk that lit a fire under me to pursue the clients with whom I *really* want to work.

Am I acting out of desperation? If you are going to borrow money or bring on a partner or investor because your business is swirling around the toilet bowl, this may be a reckless move. Borrowing large sums of money or altering your business ownership is not something easily reversed once the decision is made. If there's a serious problem in your business, throwing more money at it without fixing the underlying causes will only prolong the inevitable and make you worse off financially in the long run.

What impact will this have on my personal finances? I've seen entrepreneurs make reckless business decisions because their personal finances are a disaster. When you have your eye on short-term cash flow into your own pockets rather than long term growth and stability of your business, opportunities for reckless decision-making abound. Also, be very cautious about risking too much of your personal net worth for the sake of the business.

Is my spouse or partner on board with this financial decision? "Why would my spouse's opinion matter, if they're not directly involved in my business?" you might be asking. Your partner knows your strengths and weaknesses better than anyone else on the planet. He or she is the best person to reveal any weak points in your plan and blind spots to which you may be oblivious. And if this financial decision goes south, it *will* affect your personal finances and thus your family as well.

Is this a money move other successful businesses in my industry are making? Study the big players in your industry and watch how they operate. What needs to change in your business to play at that level? You may need to take interim steps to gradually climb to those heights, but you should be moving in

that direction. When I visited the websites of best-selling authors and big players in the coaching industry, I knew my own DIY website wasn't showcasing me as the high-caliber author and money coach I am. As my marketing coach and web designer, Fabi Paolini, told me, "You're trying to sell a gourmet meal on a paper plate. And no one pays gourmet meal prices if they're served on a paper plate." So, I invested a scary amount of money into branding and a website that truly reflects my value and expertise. And I am 100% happy that I did.

Will this expense or investment leverage my time? If you're hiring an assistant in order to delegate items on your To-Do list that aren't the best use of your time, that's likely a great investment. By removing lower-level tasks from your plate, you have more time to spend on the activities that make your business money. It's not that you're too good for those tasks; it's just not a productive use of your time. It frequently pays big dividends to hire a virtual assistant or subcontractor to answer emails and phones, manage social media, or do your bookkeeping.

Am I letting go of an activity, customer, or product line that no longer serves me? At times, our financial risk taking involves doing *less* rather than doing—or spending—more. It can be difficult to stop doing something we've always done. Maybe you need to "fire" a high maintenance customer who is a drain on your time and your joy. You might need to stop selling a product or service that occupies an inordinate amount of time and effort but has low profit margins. It's scary to let go of a current cash flow stream, even if it's just a trickle. But sometimes you need to prune away the mediocre to clear space for higher quality customers and opportunities. What would you have the time and energy to pursue if you cut customers, products, or services in your bottom 20%?

Do I have a plan to pay back any debt that I'm incurring for this opportunity? People tend to engage in riskier behaviors in business when it's other people's money on the line rather than their own. We tend to act more responsibly with our own cash than credit cards or lines of credit. If you are going to borrow money from the bank, friends, or family members for this

venture, have a solid plan from the get-go for paying it back. Preferably, ahead of schedule!

Am I investing in a potential recurring income stream? You've heard it a thousand times: "It takes money to make money." You should strongly consider investing capital into products or services that are potential on-going cash flow generators. There's nothing better than doing the work once and getting paid for it over and over again. Maybe you've been toying with the idea of creating an online video course or writing an e-book that customers can purchase on your website. You'll need to invest your time to create the videos, plus maybe even pay a professional videographer to film and produce them. Yes, it will cost money to create your online course. However, once it's completed, it doesn't consume any additional resources and will continue to make you money as long as there is a demand for your training.

This is by no means an exhaustive list of the things to consider when deciding to take a financial risk with your business. Seek the wise counsel of a business coach or other experienced business owners. And most importantly, do a gut check to determine if you are making a move out of desperation or in the long-term financial interest of your business.

CREATIVE MONEY EXPLORATION

What financial risk are you pondering in your business? How does it stack up based on the questions in this chapter? Is it a Go or a No?

PART THREE

Time: The Most Valuable Currency

CHAPTER 29

Time Is Money

Time is money and if you mismanage it, it will cost you in real dollars. The amount of money you can earn is unlimited, however, the amount of time you possess is not. Managing your time as a creative entrepreneur may be even more difficult than the money piece. When you work for an employer, time parameters are imposed upon you: beginning and ending times, scheduled breaks, recurring meetings, and lunch times. More than a few entrepreneurs feel stifled and rebel against this rigid structure, which is at least part of the reason we're self-employed. Being in charge of my own schedule is one of the perks of being my own boss. When I think about what it would be like to go back to working for someone else in an office environment, I cringe. I've actually received quite a few job offers—none of which I applied for—since going out on my own.

I'm like a feral cat. I might look exactly the same as a house cat, but I'm not. It doesn't matter how cozy the inside of the house is and how delicious the Fancy Feast food in the crystal dish, I'd feel trapped; as soon as that door opens, I'm bolting for the outside. That's how I feel about 9-to-5 Corporate America now. Even if my last employer offered me double my previous salary plus amazing benefits, I don't think I could accept it. The thought of a "real job" conjures up images of being smothered with an expensive down pillow. (So, unless I'm offered

$500,000 annual salary plus benefits to work a 9-to-5 job on the island of Maui, the answer is going to be a big "No.")

However, the transition from employee to self-employed business owner was rough for me when it came to time management. It was disorienting to go from a set schedule for the last 15 plus years to zero structure. I could do whatever I wanted, whenever I wanted to... and that turned out to be a problem! I realized that although I rebelled against military-like scheduling, I still needed some parameters to be productive. Over my first year in business, I devised my own fluid structure that worked with my peak creativity times and my obligations. It was a process and took some tweaking to get it right, but I now have something that works for me.

I have a general structure for my days and weeks, but it is flexible so I feel productive and in control rather than caged or confined. There are four key tools I utilize to master my time: personal peak times, time blocking, managing distractions, and delegation. We'll look at each one in turn over the next few chapters.

CREATIVE MONEY EXPLORATION

Become mindful of how you are currently spending your time. Download one of the free time tracking apps or worksheets online to get an accurate picture of where your minutes and hours are really going. I predict you'll have a few surprises!

CHAPTER 30

Utilizing Personal Peak Times

Identifying your personal peak times is the discovery of your own creative and productive rhythms. I've realized, through trial and error, the optimal times of the day and week for me to accomplish my best work efficiently. When I ignore these creative and productive rhythms, I pay the price with wasted time. I know I do my best first draft writing early in the morning, before my inner critic has a chance to wake up and become fully caffeinated. In fact, the majority of the first draft writing for this book happened before 8 AM. If I attempt to write first draft copy of a book chapter or blog post after lunch, it will feel like I'm slogging through quicksand. It will take me three times as long to write the same amount of words and will be half as brilliant as a first draft written at 6 AM. In fact, as I'm writing this very sentence, it is exactly 5:20 AM.

Do you know what I *shouldn't* be doing before 9 AM? I should not be returning emails, meeting potential referral partners for coffee, or scheduling social media posts. It's important for me to protect this peak creative time for writing because I am a writer. I only have two monthly recurring appointments that violate this time for which I make an exception. These two meetings usually result in increased sales for my business, so I *choose* to allow them to infringe on this precious time.

It's vitally important you identify your peak creative production time and protect it in your schedule. For me, this is 6 to 8 AM. Do I write for two hours every single weekday? Of course not. However, if I didn't block it out in my schedule, my writing production would be severely diminished. I find that I also do better with highly detailed tasks earlier in the day, so I make it a point to knock those out before noon. Phone calls, meetings, and anything else requiring collaboration seems to flow more easily for me in the afternoons.

Rest assured, I'm not attempting to turn you night owls into early birds. You might find you're the complete opposite of me, and your best creative production happens in the late afternoon or evening hours. Find and identify the "right time" for you to do the following work in your business: creative production, collaboration (meetings and phone calls), promotion (sales, marketing, social media), and money management (invoicing, banking, bill paying). Your peak time for song writing might be at 10 PM, so ensure you're not spending that time binge-watching Netflix or cute kitten videos on Facebook.

CREATIVE MONEY EXPLORATION

Over the next few days, pay attention to the times of day when you feel "in the flow" with the following activities: creative production, collaboration, promotion, and money management. Note when you feel each task comes the easiest to you: early morning, late morning, early afternoon, late afternoon, early evening, or late evening.

CHAPTER 31

Time Blocking

N ow that you've identified your optimal times for certain types of work, block out time for them on your calendar. Some of my work, like writing, is scheduled daily, and other tasks like marketing and accounting are scheduled weekly. Here's what a typical week looks like for me.

Mondays are my "Planning and Content Generation Days." I take some time in the morning, or sometimes even over the weekend, to write out my master To-Do list and map out my week. Once that's accomplished, I go to the office, pop on my headphones with ocean sounds playing and crank out content. This may be articles that I'm being paid to write for national finance websites, my own blog posts, lessons for a new online course, newsletter or sales copy. I do my best to wait until late afternoon to respond to emails or return phone calls.

Tuesdays, Wednesdays, and Thursdays are big days for in-person classes, coaching, and meetings. For some reason, companies tend to pick Wednesdays and Thursdays for me to come in and teach their employees about Money Wellness as lunch-and-learn sessions. It's also common for me to have face-to-face coaching appointments with clients in the evening on these days. I fill in the time with lunch and coffee meetings with my best referral partners. I usually have some time in between appointments to answer emails and return phone calls.

Since I usually work half a day on Saturday in the morning, I generally only work part of the day on Friday. Yes, I have my writing time first thing in the morning, then I usually do some networking in the form of my women's group that meets twice a month, or coffee with a referral partner. But come lunchtime, I am free to go and do something fun like going to the pool or playing 9 holes of golf with my mom in the summer or wandering around the Cincinnati Art Museum or the local antique mall in the cooler months. I've even been known to take myself to an afternoon movie—yes, alone! As Julia Cameron recommends in her book, *The Artist's Way*, these "play-dates" with ourselves keep our inner artist nurtured and inspired. The quality of your artistic production will deteriorate if you don't have rest and recreation built into your weekly schedule.

On Saturdays, I usually work for three to four hours in the morning. This allows me to catch up on writing projects if I slacked on my word count production during the week. After writing time, I'm catching up on all the little odds and ends on my To-Do list. I almost never work on Sundays; I forbid myself from turning on the computer. I reserve that day for rest, family, and spiritual refreshment.

Your weeks may not typically include meetings, networking events, or customer calls, but rather larger swaths of time for creating and refining your art. The particular types of time blocks will be unique to your creative business.

Most humans are deluded into thinking that they are great multi-taskers. But the truth is by shifting gears frequently between differing tasks, you are less efficient. Why? Because it takes time for your brain to get back in the flow when you hop from one thing to the next. This is why time blocking your work is so important. However, there are certain tasks that can be stacked together *without* the negative consequences of shifting gears.

When you stack a physical task with a mental task, even though they may be worlds apart, you can make the most of your time. For example, if I am eating a meal by myself, I'm almost always reading a book or a magazine. Reading engages my brain and eating engages my body. I laugh when somebody tells me

that they don't have time to read. Of course, as a certifiable Word Nerd, I'd rather miss a meal than miss a book. (Which is saying a lot, because I get pretty hangry if I miss a meal!) When I'm driving to a client appointment or meeting, I listen to audiobooks in the car or return phone calls via Bluetooth. When I'm working from home, I may be folding laundry while making follow up calls to prospects.

When scheduling meetings or errands, try to group them on particular days of the week or in certain parts of town. I do my best to schedule meetings on the south side of town on Wednesdays and the north side on Thursdays. It doesn't always work out perfectly, but it's certainly more efficient than when I was making my appointments haphazardly. Yes, you should pick up your dog's medication from the vet after your customer meeting if the locations are only a mile or two apart, rather than making a special trip on another day. Being intentional with your schedule will save you both time and money.

The final and most important thing you need to block out time for is margin. You must intentionally build in times of rest, recreation, and relaxation into your schedule. Traditionally employed folks have a quitting time and you should too! I generally stop working at 5 PM so Nick and I can eat dinner together, unless I have a coaching appointment, class, or webinar. But as soon as the webinar or coaching call is finished, I shut down the laptop and go relax with my husband in front of the TV with an episode of *Ancient Aliens*.

As I said, it's extremely rare for me to work on Sundays. As a self-employed creative, it's important that you build in these buffers as well. If you don't properly recharge and rest, your creative work will suffer.

CREATIVE MONEY EXPLORATION

Write down 10 fun things that recharge or refresh you. Set aside at least 2 hours this week and go do one of them.

Look at your schedule over the past few weeks. How can you ensure that you are reserving your peak creativity time for production, rather than wasting it on things that can be accomplished at other times? Block out that time on your

calendar and guard it with a vengeance. Be sure you're scheduling in margin, recreation, and relaxation.

CHAPTER 32

Avoiding Time Leeches & Distractions

We know we should protect ourselves from the obvious time leeches and distractions: the constant checking of our social media accounts, watching TV and online puppy videos, gaming, browsing for the perfect winter hat on Etsy. But there are other sneaky leeches that siphon off precious time from our creative production reserves. If you work from home, it might be tempting to rearrange the living room furniture rather than make follow-up calls to potential customers or work on a project that's hit a creative roadblock.

Sometimes we'll allow distractions that seem justified— "The laundry's not going to do itself!"—to avoid work that needs to be done. I'm not saying you can't take a break from computer work to wash a sink full of dishes or pick up your dry cleaning during the workday. That's one of the perks of being self-employed! In fact, I use the sound of the washer and drier buzzers to remind me to get up and take a stretch break from the keyboard, but I don't use it to avoid work. (My distraction drug of choice is Facebook or email.)

Speaking of social media, I try not to even check my phone, email, or Facebook until after my morning writing session. These things fill my head with mostly pointless distractions that I'm not going to do anything about until after my writing time

anyway. This unnecessary chatter impedes good quality first draft writing, so I protect myself from it. When I fire up my laptop, I keep my browser closed until 8 AM.

Another trick to prevent digital time leeches from eroding your precious time and productivity is to set limits. Rather than checking your phone every 5 minutes due to FOMO (fear of missing out, for those of you who have been living under a rock), have set times of the day to check your email and social media alerts. I've set my phone so it does not "ding" when I receive an email or social media alert, which has drastically reduced the number of times per day that I check it. Every time you check your phone, it makes it harder to return to the deep creative flow that most of us need to do our best work. There are even apps you can download to help limit the total amount of time you spend on social media; they can be set to block you from accessing it at certain times of the day. If you know you have issues with this, such an app would be well worth the money. If I'm waiting at the doctor's office or arrive early to a meeting, I'll kill a few minutes scrolling through my Twitter or Facebook feed without it negatively impacting my productivity.

People can be another distraction for us creative entrepreneurs. I'm surprised how often I'm preparing to log into QuickBooks to update my business accounting, and I suddenly realize it's been several days since I've talked to my Mom—30 minutes later, I hang up the phone, and now I need to head out the door so I'm not late for a client meeting. A better way to do this would be to suppress the urge to pick up the phone now and take care of my QuickBooks. Then I can dial my Mom and talk via Bluetooth on the way to my appointment. My work is accomplished and Mom is not neglected!

Sometimes, the people in our lives will assume that because we're self-employed, we can just drop everything we're doing to be at their beck and call during the week. It's happened to me, too! A friend or relative calls or texts the night before needing a ride to the airport or doctor's office, then gets mad when I tell them I can't do it. "I thought you worked from home and made your own schedule?" Yes, I do make my own schedule, and I certainly don't wait until the night before to do it! Just because

your office is based out of your house doesn't mean you're at home from 9-to-5, Monday through Friday. Now, this certainly doesn't mean you never make exceptions, especially if it's an emergency. However, it's important to set boundaries in your life regarding your schedule. If you are going to help a friend or family member out, be sure it's not habitually impacting your business and productivity in a negative way.

Before I joined my coworking space, one of my go-to ways to shut out distractions and time leeches was packing up my laptop and heading to the library. The library is the mecca of peace and quiet, and one of my favorite places in the world. (In fact, I'm editing this chapter from the library right now!) I fire up the laptop, put on my headphones and listen to the sound of rain or ocean waves on my "Rain, Rain" app. If I have an appointment cancel and it's on the other side of town from my coworking space, I'll head to the nearest library branch, rather than heading home where an army of distractions await me.

Learn to say "no" quickly and "yes" slowly when someone requests your time. We are presented with many opportunities to spread ourselves thin. Be discriminating with the opportunities to which you say "yes". When someone asks me to attend an event, meeting, or other outing, here's what I say: "Wow, that sounds amazing! Before I say yes, let me check my schedule and I'll get back to you by Friday." This gives me time to consider the event in light of everything else I have going on before I commit. Some things to think about before saying yes: Am I excited about attending this event? Will there be people of influence attending the event whom I should meet? Does this event present an opportunity for visibility for my business?

What if I decide to decline? Here's how I let people down gently: "Thank you so much for inviting me to next week's event. I won't be joining you this time, as I have another commitment. Have fun without me!" That commitment can be the one you keep to yourself for a relaxing evening of Netflix and pajamas.

CREATIVE MONEY EXPLORATION

Over the next week, make a note of the things that distract you and leech away your time (you may have discovered these during your time tracking experiment in chapter 29)—and how much time they have cost you.

What are your biggest non-productive time sucks? What strategy will you implement to stop your precious creative time from going down the drain?

CHAPTER 33

Time to Manage Your Money

A s part of your time blocking exercise, set aside time daily, weekly, and monthly to review the money details of your business. Depending on your business, you may or may not need to do this daily. If you own a spice shop, hair salon, or an antique store with a multitude of daily transactions, you'll likely need time at the end of the business day (or early the next morning) to tally your total sales numbers and prepare a bank deposit. However, if you're a fashion photographer or marketing coach with an average of three customers per week, it would make more sense to invoice and pay bills weekly versus daily. Set aside time at least weekly to take care of your business accounting.

Do this when you are well rested and will have a minimum of disruptions. Be sure that it does NOT infringe on your peak creative time.

Here are the money-related items to do on a weekly basis:

- Invoicing
- Categorizing your expenses via your online accounting program
- Filing receipts and customer contracts
- Paying bills

Once a month, in addition to your weekly money checklist, you should be doing the following:

- Business mileage and expense report
- Matching receipts to bank statements
- Looking at your financial statements

Once a quarter, you need to mail in your estimated tax payment, which your CPA or tax professional will calculate for you.

If cash flow is tight, feel free to send out invoices to customers immediately, rather than waiting for your weekly money session. The same goes for bills that need to be paid right away. Most businesses that fail, do so because of underfunding or cash flow problems. By invoicing at least weekly, this will ensure that customers are paying sooner rather than later. If you don't stay on top of paying your business bills, that can result in late fees, penalties, and interest. Getting into a weekly flow of money management will prevent both problems.

One painter I interviewed has a trick for making herself do the "unpleasant" (her words, not mine!) task of business paperwork. She sets a timer for 5 or 10 minutes and starts working. When the time goes off, she gives herself permission to stop and do something else. Knowing that she can quit after the 5 or 10 minutes drastically lowers her resistance to starting. Many times, she continues with her filing, organizing, and bookkeeping even after the timer dings because she's now in the flow and motivated to finish it.

Another way to bribe your inner artist to spend a little time managing your money is to give yourself a small treat when you're finished, like a Belgian chocolate truffle or a mug of your favorite craft beer. It's essentially parenting yourself, "If you don't eat your vegetables, then you don't get dessert!"

Ensure that your environment for managing your business finances is a pleasant one. If you always invoice customers and pay bills at a card table in your undecorated spare bedroom with a folding chair, no wonder you dread it! This space can certainly

be separate from your creative workspace, but it should be comfortable and yes, even whimsical. Play some soothing music you enjoy and fix yourself a cup of your favorite tea or coffee. Light a scented candle, if that's your thing. I usually do my business accounting at my home office, which is filled with the things I love: books, unique wine bottles, and a small stuffed white rabbit, a la Alice in Wonderland, to remind me to follow the rabbit trails of my creativity.

CREATIVE MONEY EXPLORATION

What day of the week and time will you consecrate for your "play date" with your business finances? Feel unmotivated? Try the timer trick and see if it works for you. Decide on a small treat to reward yourself with once you're finished. How can you spruce up your accounting space so that it's more inviting?

One of my creative entrepreneurial friends says she channels her "inner accountant." Try pretending you're an actor in a movie and your role is that of a nerdy, super-smart accountant. Do this right before you pay your bills or update your business financials.

CHAPTER 34

Buying Back Your Time

We live in the DIY age. Turn on the TV, watch a YouTube video, or find a tutorial on Pinterest—and you can learn how to renovate your house, bake a fluted pie crust, or fix your leaky toilet. You've heard it a million times: "Time is money." When you first start your business, money is tight so you do everything yourself, even if you don't do it well. But just because you *can* do it yourself, doesn't mean that you should.

I've heard small business owners say, "Once I'm making a little more money, *then* I'll hire someone to do my books, answer the phone, and file my paperwork." However, I'm asserting that the reason you're not making more money and being as successful as you'd like is because you're wasting your valuable time by doing your own books, managing social media, and filing paperwork. I know because I've been guilty of it myself. If you want your small business to grow, you absolutely must leverage your time! In fact, you can't afford not to.

Where is your time best spent? For most business owners and entrepreneurs, it is interacting with potential customers, servicing current clients, and producing your products and services. For me, my time is best spent bringing light into the financial darkness of others. I do that through my coaching, teaching financial wellness classes, speaking to groups of people, and via my writing. I make between $250 and $450 per

hour or more on these activities. Anything that is not coaching, teaching, speaking, writing, or selling those services, I offload to someone else. When I have a recurring to-do that's not in my sweet spot, I consider two things: How much time will I save by leveraging this? And how much can I potentially bill by having this time available for my customers?

Delegating is a challenge, especially for those of us who are control freaks. No one can do it better than we can! Plus, it takes time to find the right person and train them if we are willing to delegate at all. But here's the thing: you can always make more money; however, you have a finite amount of time on this earth. Two years ago, I heard a success guru say, "If you want to be wealthy, stop cutting your own grass and cleaning your own toilet." At first, I thought he was just being a snob, until he continued to explain why. "You can make *way more money* per hour in your business than you'll ever pay someone to cut your grass or clean your house." I was intrigued, partly because I hate cleaning toilets and mopping my floors, so I investigated how much a cleaning service would cost me.

My cleaning lady quoted me $150 to come into my house twice a month to clean. She cleans the bathrooms, vacuums, sweeps and mops the floors, and dusts each time. Plus, there are cleaning chores she does for me monthly and quarterly that are worked into the rate, like windows and baseboards. I am paying her for 6 hours of cleaning, but because she is a pro, she is saving me 10 hours of housework per month. If I do a one-hour coaching appointment, I have more than paid for my cleaning lady for the month! Yes, my cleaning lady "costs" me $25 per hour. However, I am buying back 10 hours of time every month for $15 per hour. And I charge my coaching clients more than 20 times that rate. You best believe that's a damn good deal! Even if she doubled her rates, I'd still come out way ahead. Now, if only I could figure out how to convince her to come to my house every night after dinner and wash my dishes...

I also have a VA (virtual assistant) who does a variety of clerical and marketing tasks for me in my business. Of course, I could send out my own email newsletters, post my blogs to my website, and apply my new branding to all of my PowerPoint

presentations, but is that really a good use of my time? Not really.

The cool thing is that leverage comes in two forms: other people (as in my cleaning lady and virtual assistant) and time-saving tools. Sometimes, you're not hiring another person to do something for you, but you're using a tool to save you a substantial amount of time. For example, using an online accounting program such as QuickBooks, saves you data entry time because it's pulling in your transactions in from your bank account automatically. There are tools you can use to help automate scheduling appointments (TimeTrade.com), manage social media posts (Buffer.com), track the opportunities in your sales pipeline (Pipedrive.com), and the list goes on. Automating these otherwise time-consuming tasks is a great way to leverage your time for a small amount of money.

How can you effectively delegate both personal and work tasks to free up your time to produce results in your business? Make a list of the tasks you do personally and in your business daily, weekly, and monthly. Which of the items on your list do you dislike or are a struggle for you? Which tasks just suck the life out of you? Which are just busy work, not generating any profit for you? Chances are these can be offloaded to another person who loves to do those things! You should be concentrating your time and energy on those things that you love to do and come easy for you. If you're not a numbers person, which I suspect you may not be, you should hire a bookkeeper or CPA to help you with this. A bookkeeper will do it faster, better, and cheaper than you can do it yourself.

The obstacle many entrepreneurs have is thinking that no one can tackle their To-Do list as well as they can, and with your core products and services it may very well be true. But I'll bet you can find someone who can file, organize, clean, promote, and answer the phone as well or better than you can! Calculate how much money you will need to cover the cost of outsourcing the things you want off of your plate. How much extra will you need to sell per month? Instead of saying, "I can't afford to pay for help," ask, "How can I afford to pay someone to do this for me?" Like me, you might discover that you only need to sell one

extra coaching appointment or painting or photo session per month to afford 10 hours of help.

CREATIVE MONEY EXPLORATION

I've seen multiple variations of the following exercise by business gurus and coaches over the years. This version, assigned to me by my business coach, Jenn Scalia, freed up almost 8 hours every week to spend on creative production in my business!

Do - Delegate – Delete: Write down all the things you are doing in your business on a daily, weekly, or monthly basis. Next to each activity give it a ranking of 1 to 10 as to how much you enjoy doing it, with 1 being "hate it," and 10 being, "love it!"

Then, go back and give it a second ranking from 1 to 10 as to how profitable this activity is for you, with 1 being "zero financial benefit" and 10 being "rolling in the cheddar!"

Now, reorder your list with the activities ranking highest on both fun and money coming to the top of the list, and the lowest going to the bottom.

Top of the List: This is what you should DO! The activities that are 8+ in both enjoyment and profitability you should invest major time in.

Middle of the List: This is what you should DELEGATE. These activities may be leading to profitable opportunities, gaining you visibility, or may be essential for taking care of your customers. But it doesn't necessarily have to be you that's doing them.

Bottom of the List: This is what you should DELETE. Unless it's something required by law, remove it from your schedule. Sometimes, we do things out of habit and assume they're good for business until we dig into the details and realize we're wrong.

See the Creative Money Exploration Guide for an easy-to-use template.

PART FOUR

Exploding on the Scene

CHAPTER 35

In a Vanilla World, Be a Pistachio

A colossal mistake business owners make is throwing money at marketing and advertising without first considering these two vital questions: *Who is your ideal customer? What problems are plaguing them that you can help them fix?* Contrary to what you may believe, "anyone" and "everybody" are not your ideal customers. You can't be all things to all people because your message will be so watered down, you won't attract anyone. If you try to appeal to everyone, you'll end up with a forgettable, plain vanilla brand. Sure, nobody hates vanilla, but does anyone really rave about it or rail against it, like pistachio?

Focus and consistency are key to capitalizing on your marketing dollars! We have this misconception that, if we focus too narrowly, we will exclude paying customers, but the opposite is true. Think about aiming an arrow at a target. If I concentrate on the bullseye, there's a high likelihood, with practice, I will consistently hit it or at least get close. If I notch an arrow in my bow and let it fly down range without aiming, there's almost zero chance I'll hit the bullseye and I might not even hit the target. The difference is focus.

It's vital to distill your message to its essence so others can easily remember it and repeat it. Think of this as your "Tweetable tagline." My friend, Candra Evans owns a natural body care products company called Abundantly You Bath and

Body. Her tagline is "Abundantly You Bath and Body, where we are passionate for all things naturally beautiful." This paints a word picture and draws people in, wanting to learn more.

Additionally, you need a slightly longer version of this, which is commonly referred to as the "elevator pitch." It gives enough detail for the listener to know what you're selling and to whom but it's short enough to say during a brief elevator ride. Here's Candra's elevator pitch as an example: "We handcraft bath and body products that are nourishing and refreshing for the hair and skin. Abundantly You products are fragrance free or beautifully scented with natural essential oils and unrefined butters. We also provide a wide variety of vegan skin and hair products. Abundantly You Bath & Body is 100% cruelty free and environmentally friendly, because looking after our earth is important to us." It's short, simple, and impactful.

Abundantly You Bath and Body products are targeted to individuals who want to use natural products that are kind to their skin, animals, and the environment. Does this mean that Candra won't sell her body care items to people who think the products just plain smell delicious but aren't necessarily concerned about naturally sourced ingredients? Of course not. But when she's focused in her marketing, Candra will be selling to customers whose values closely align with her own on a regular basis. As a bonus, being specific also assists you in filtering and targeting people with your paid advertising. *Who is your bullseye?*

Don't worry if you're not in love with your tagline or elevator pitch yet. Mine has evolved greatly since my first year in business when I used to say, "I'm a certified financial coach who helps people who are struggling with money and drowning in debt." (YAWN.) What's funny is back then people would say, "I know plenty of folks who need you!" but they never sent me any referrals. Now that I have fine-tuned my own tagline and elevator pitch, I'm receiving more high-quality referrals than ever! People are now intrigued when I say, "Hi, I'm Christine Luken, the Financial Lifeguard. I empower high-earning professionals and entrepreneurs to rescue their financial dignity." They almost always want to know more!

In her best-selling book, *Your First Six Figures: Eight Keys to Unlocking Freedom, Flow, and Financial Success with Your Online Business*, author Jenn Scalia encourages her readers to take a strong stand for their values to purposely polarize people. This attracts your raving fans like a magnet and repels your non-ideal customers (remember pistachio ice cream?). To do this, Jenn suggests making and publishing a list of the "Top 10 Reasons You Shouldn't Work with Me." By clearly stating what you DON'T stand for, you're highlighting what you DO stand for. Here's my list:

Top 10 Reasons You Wouldn't Hire Me to Be Your Financial Lifeguard

#10 You enjoy sleepless nights, tossing and turning, worrying about money.

#9 You love paying out a large percentage of your income every month to credit card companies.

#8 You like watching tumbleweeds blow through your savings account.

#7 You think that financial dignity and mastering your money are highly overrated.

#6 You want a money coach who can't sympathize with your situation and will put you on the same cookie cutter plan as all his other clients.

#5 You enjoy arguing with your significant other about money.

#4 You love the sense of shame and anxiety that washes over you when you check your bank account balances.

#3 You want to work hard until you're 99 years old because a comfortable retirement in a tropical location doesn't appeal to you at all.

#2 You enjoy wasting your hard-earned money on things that really aren't important to you or your family.

#1 You'd rather hire a financial coach who cuts up your credit cards, puts you on a restrictive budget, and berates you for your foolish money mistakes.

As you can see, it's sarcastic and a little humorous (like me!) and it lets potential clients know what to expect. So, unless you're in a somber profession, such as a makeup artist at a funeral home, this can be an amusing and effective exercise to drive business your way.

Who are your low-maintenance, high-dollar customers? Who are the people that are a joy for you to serve? Focus on them! Once you understand your ideal client and their problems, you can craft your marketing in a way that speaks directly to their pain and draws them to you as the solution. Pay attention when you are with your dream customers and listen to the exact words they use to describe their problems and your solutions. (Take notes and write them down!) Then use those words to market to more people just like them.

Once you've clarified your message, be consistent with it across all of your marketing materials and social media platforms. The quickest way to drive customers away is to confuse them. Certainly, you can have multiple products or services, but they should be unified under your "Tweetable tagline." I offer 1-to-1 coaching, online courses, money wellness in the workplace, and membership groups—ALL of which empower my clients to rescue their financial dignity in some form or fashion. Everything I do must pass that litmus test.

On average, it takes seven advertising impressions before a potential customer takes action to buy. In order to increase the likelihood of your dream clients clicking on your ad, you better put your best foot forward so you're not wasting money. Even if you are going the low-cost or free route of marketing yourself through your website, email blasts, or social media posts, you're going to waste precious time and effort if your message isn't focused on the bullseye. Yes, you will get some interest from people who aren't dead center, but you're less likely to attract people way outside of your target.

Your marketing message should help you sell your products and services, greasing the skids for your sales process. If your message is consistent, focused, and flavorful, sales will flow your way more easily and often. In a vanilla world, be a pistachio!

CREATIVE MONEY EXPLORATION

Write out the first draft of your Tweetable Tagline and Elevator Pitch.

CHAPTER 36

The Art of Networking

What comes to mind when you hear the word, "networking?" Do you picture a sea of professionals in black suits at the chamber of commerce, swapping business cards and shaking hands? Do you shudder at the thought of it? Certainly, that's the most obvious incarnation of networking. However, the true art of networking is more subtle and creative.

For many of us, networking is synonymous with selling. But the heart of networking is simply this: two people connecting with each other for mutual benefit. Networking happens at art galleries, bourbon tastings, campus libraries, and even on the sidelines of your kid's soccer game. It's not just something that occurs at structured business events. I'd like to challenge you to change your definition of networking from "selling" to "connecting."

I abhorred networking when I first started my business. When I worked a traditional job in HR and accounting, I rarely went to networking events because I didn't need to. My paycheck didn't increase one dollar by going to those types of events, so I rarely bothered.

However, once I quit my day job to be the Financial Lifeguard full-time, I knew it was necessary to get out in the world and meet people if I wanted to grow my business and feed myself. For a year and half, I floundered about like a fish out of

water desperately attempting to make connections at my local chamber of commerce and various gatherings of HR managers. As I walked in the room, my only positive thought was that this networking event would be over soon and I could go home. I would look around the room, realizing I knew no one, and feel my anxiety rise like a tidal wave. Maybe I could just hide out in the ladies' room for an hour, feigning illness?

My natural inclination is to be introverted. (Maybe yours is, too?) I'm pretty sure I could live quite happily with my sole companions being stacks of books, my husband, and a cat or two. Growing up, I always had a small, close circle of friends. I wasn't the popular one or the center of attention. My brother, a natural comedian and athlete, would actually have different groups of friends fighting over him on Saturday nights, wanting Jim at their parties. No one was fighting over me back then!

So, how did I go from being a wallflower to a networking boss? The process involved learning the proper techniques, plus time and a whole lot of practice. I absorbed all the information I could and joined a formal networking group. Each week, I stood up in front of 40 people and pitched a one-minute "commercial" about my business. Each week, my palms would sweat and my heart raced before it was my turn to talk. Honestly, it probably took a good six months before I stopped feeling like I was going to die of a heart attack before I stood up and talked.

Why did I put myself through this torture? Because I knew I had to push through my discomfort if I wanted to grow, change, and improve. The almost four years I spent in my networking group transformed me into a confident and professional speaker, both in a group setting and in one-on-one conversation. I'm not saying you necessarily need to go this exact route yourself, but if your ideal customers are in Corporate America you may want to consider it.

When you realize that networking is really about connecting with one person at a time, it becomes less intimidating. You might be in a room with 50 people, but your focus should be firmly fixed on the one person you're conversing with right now. Do you want to know a secret to endearing people to you almost immediately? Ask them questions about themselves and their

business and really listen to what they're saying. Think about people you already know to whom you could introduce them, in order to help them in some way.

I love the little book, *The Go-Giver*, by Bob Burg and John David Mann. It's a parable contrasting the traditional "go-getter" philosophy of business versus the "go-giver" approach. This story is all about the power of giving, karma, and reaping what you sow in your business. If you help someone out by making a connection, sending them an article to help them solve a problem they mentioned, or by referring potential customers their way, you're golden. Guess what this person will want to do next? Help you! And many times, they'll help you without you even asking and in ways above and beyond what you'd imagine!

Where should you network? The answer is going to be highly individualized based on your business, your target audience, and your location. First and foremost, you want to be where your potential clients are gathering. If business professionals and corporations are your target, your local chamber of commerce or industry-specific groups would be an excellent place to start. If you own a retail shop, see if your city or town has a business council you can join. You might consider plugging into a group that is slanted towards professional development or supports a cause you believe in. There are also structured networking groups, like Business Network International (BNI), which contain a wide range of professions and have a significant training component to improve your networking and presentation skills.

Visit each group several times before joining. Consider asking a current group member (but not the person trying to sell you the membership) for coffee to ask them about their experience. Find out both the cost in dollars and the time commitment involved. Yes, you want to invest time in cultivating connections and reaching potential customers, but networking shouldn't be your second job. If you're not careful, you'll find yourself belonging to six or seven different groups and wonder why you have no time to do your actual work.

Evaluate your networking groups every six to twelve months. How much business did you give versus the business

you received? You want to ensure you're getting a positive return on your investment. During your first six months in a new group, you might not receive much in the way of income, so don't be discouraged. People are just getting to know you and your business. It takes time to build creditability, which should lead to profitability. If you're not getting a good return for your efforts in your second six months, one of two things is a problem. One, you're in the wrong group. Or two, you're not a very good networker! If you're in three organizations and not getting a return on any of them, your networking skills probably need an upgrade. Reading the book, *Avoiding the Networking Disconnect*, by Brennan Scanlon and Ivan Misner will help you do just that.

As your business grows and changes, your networking activities and the groups might need to change, too. We are creatures of habit and comfort, but don't allow yourself to fall into a networking rut! Are you meeting new people in your current groups? Balance nurturing existing connections with making new ones. Maybe there's a group you love attending because of the friendships, but there's no really tangible business flowing your way. If you want to continue because of the moral support you receive, that's totally fine. But don't kid yourself; that's socializing, not networking.

Don't approach networking as a dreaded task to check off your To-Do list. Others will sense that from a mile away and steer clear of you. See it as a quest to discover new and exciting people who may hold the key to unlocking new levels of success in your creative business.

CREATIVE MONEY EXPLORATION
If you're not networking on a regular basis, find two or three groups to try out over the month.

CHAPTER 37

Multiply Your Income with Referral Partners

One of the most important lessons I learned from my first business coach, Nanette Polito, is the importance of having great referral partners. A "referral partner" is someone who is in a non-competing, complimentary business to your own. Your referral partners are in constant contact with your ideal clients, but they don't compete with you. Great referral partners will help you grow your business, and you'll be able to offer your customers more solutions through them. These are the people who are talking good about you behind your back!

For example, in my Financial Lifeguard business, my best referral partners are financial planners, accountants, divorce attorneys, bankers, and a college planning expert. My ideal clients—busy professionals and entrepreneurs—are already getting "financially naked" with these people, talking about money related topics. My referral partners are in a great position to determine if their clients need my assistance with creating a prosperity plan. My referral partners offer services complimentary to my own. I don't sell investments, insurance, tax prep, or estate planning services but many of my financial coaching clients need this help. A photographer may have referral partners who are a jeweler, a wedding planner, a bridal shop owner, and the manager of an event center.

Do you have referral partners for your business? Besides offering complimentary services or being in proximity to your ideal customers, what are other things to consider when choosing referral partners?

Are they people of integrity who are truly going to take care of your customers' best interests?

Are they willing to learn in depth about your business, products, and services? (You must be willing to do the same for them!)

Are they willing to reciprocate referrals? Just be aware that true referral partners aren't keeping score with how many referrals each has sent the other, but there should be a healthy flow back and forth.

Are they willing to set up a weekly time to talk to you for 10 – 15 minutes to discuss ways you can help each other?

Having mutually beneficial relationships with referral partners amplifies your reach in the marketplace without spending an outrageous amount of money on marketing and advertising. Most times, the referrals from your partners will be pre-qualified and already sold on you and your solutions.

CREATIVE MONEY EXPLORATION

Write down professions that serve the same customers you do yet are not your competition. Who do you know in these professions? Are they referral partner material? Set up a meeting with them to discuss the possibility of intentionally referring business to each other. Whom do you need to meet in professions where you don't have a potential referral source?

PART FIVE

Selling is Serving

CHAPTER 38

Becoming a Student of Sales

You must become a student of sales to succeed in business. It's not enough for you to create beautiful art, a spectacular product, or innovative service. It's not enough that you're a nice person who delivers excellent customer service. Why? Because if no one knows you exist, they're not going to hire you or buy from you.

When I worked for my family's business, I constantly razzed the sales staff, including my brother, Jim, the VP of Sales and Marketing. I considered sales to be a slimy profession, where you had to use sneaky tactics and bend the truth to get an order out of a customer. I even printed up a poster sized picture of Herb Tarleck, the checkered sport coat-wearing sales rep from the old TV show, *WKRP in Cincinnati,* with the caption, "It's not lying, it's sales." When I left the company to strike out on my own, I swore that I wouldn't stoop to "selling" my financial coaching services.

Three years later, my business still wasn't at the level of income I had hoped. It was growing, but at a painfully slow rate. Gee, I wonder why? I depended solely on referrals and word of mouth. Referrals are great when you receive them; however, they are dependent upon other people. I knew that if I ever wanted to be a successful Financial Lifeguard, I had to lose my preconceptions about sales and become a student of it.

My friend and business associate, Glenn Warner, recommended I read Grant Cardone's book, *If You're Not First, You're Last*. Finally, someone was able to explain to me the importance of sales, the specific techniques, and the action plan to put it all in place, while making me laugh in the process. I devoured all of Grant's sales books, reading all of them multiple times and having lengthy discussions with Glenn about them. Here are the nuggets regarding the importance of selling that really impacted me:

If you're really sold on yourself, your products, and your services, you'll realize that *a sale is all about serving the other person.* In my case, I'm not simply selling coaching, books, or programs; I'm offering financial dignity. If I believe in myself, I'm doing a disservice to others by *not* telling people how I can empower them to reduce their money stress, improve their marriages, and increase their bottom lines.

You should be doing sales activities on an almost daily basis. Selling isn't something you do once a month; it needs to be like breathing. It's all about spreading the word about how you can help people solve their problems. There's nothing slimy about that! As Grant Cardone says, "Obscurity is your biggest problem."

It's imperative to track your sales activities and opportunities. I started using an online CRM (customer relationship management) system called Pipedrive.com, which only costs me $12 a month. It tracks all of my opportunities and the tasks related to them. I receive a daily email with my sales To-Do list every morning, so nothing falls through the cracks. It takes only a few minutes daily to enter in new leads and update my activities.

You need to immerse yourself in sales education and have other like-minded people in your inner circle. Several years ago, I signed up for Cardone University, Grant's online sales training. Every weekday for six months, I spent at least 15 – 30 minutes learning something about sales: prospecting, follow up, closing, etc. I discussed the sales principles with other small business owners in my network and bounced ideas off them as to how to apply the techniques to my business. I continue this self-

education by reading or listening to several books a year on sales, marketing, and negotiating.

Sales is merely the process of helping your customers purchase the solution to their problems; it's serving others. If you're a self-employed creative, selling is the lifeblood of your business. If you want to increase your income, you'll need to level up your sales skills. Don't hate the one thing that can skyrocket you to success! Unfortunately, your art will usually not sell itself.

CREATIVE MONEY EXPLORATION

How do you feel when you hear the word sales? (Be honest!) If it has a negative connotation for you, as it once did for me, try replacing the word selling with serving. Are you selling on a daily basis? Do you have an easy way to track the leads in your sales pipeline? Buy a book on sales and commit to reading or listening to it this month.

CHAPTER 39

Why No One Is Following Up

A t this moment, I can think of three business owners whom I've recently told in passing that I want to buy one of their products and services. Guess how many of them have followed up with me to make the sale? Only one. I hate to say it, but I experience this on a regular basis. Sometimes, I will go back to that person and say the equivalent of, "Please sell me your product. Take my money!" Other times, I will buy someplace else because they didn't seize the moment to close the sale.

Why are so many creative entrepreneurs terrible at follow up? And by "follow up," I mean staying in touch with people or companies who have expressed interest in buying from you but haven't done so yet.

Here are 3 common reasons you're not following up.

You're busy managing all the various parts of your business. Look, we're all busy, but as business owners, our #1 priority needs to be following up with potential customers who have shown interest in our products and services. Clerical work, social media, marketing and other tasks can easily be delegated to a VA (virtual assistant) to free up your time to close more sales.

You lose track of opportunities because you're disorganized or don't have a system. This is the equivalent of allowing hundred-dollar bills to slip through your fingers. The

fix for this is easy—lead tracking software or websites like Pipedrive.com are worth their weight in gold. I love using Pipedrive, because it shows me where all my leads are in my pipeline and the potential dollar value. Plus, I receive emails daily reminding me of my follow up tasks.

You feel like you are bothering the people who want to buy from you. (Read that last sentence out loud. Sounds kind of ridiculous, right?) If a potential buyer asks you to follow up with them next month, follow up with them next month! That's not bothering them if they *ask* you to do it! Your customers and prospects are busy people. They may forget about you if you don't stay in touch with them. This doesn't have to be hard. Just call them and say, "Hi John! You asked me to give you a call this month to touch base with you and see if you wanted to move forward with your purchase of (insert your wonderful product or service here)."

Here are true and somewhat shocking stats on sales follow-up:

- 2% of sales are made in the first contact with a prospective buyer
- 3% of sales are made in the 2nd contact
- 5% of sales are made in the 3rd contact
- 10% of sales are made in the 4th contact
- 80% of sales happen between the 5th and 12th contact with a prospective customer!
- 48% of people never follow up
- 25% of sales people make a second contact and stop
- 12% of sales people only make 3 contacts and then stop
- Only 10% of people make more than 4 contacts to a prospect!

And here's the thing, each time you contact the person, you don't have to outright ask them to buy from you. Maybe you have someone you'd like to introduce them to who might be a

good connection. You could forward them an article or blog post they would find interesting. Sometimes, I have called prospects just to catch up with them and see if there's anything I can do to help them. Many times, they will bring up my products or services before I do and say they're now ready to buy.

CREATIVE MONEY EXPLORATION

Grab a pen and write down at least 3 people who expressed interest in your product or service in the last 30 days. Schedule time in your calendar to call them in the next 48 hours and FOLLOW UP. The sooner you follow up the better. If you wait too long, your window of opportunity may be closed. When you make your calls and score a sale, tag me on social media and tell me. I will celebrate with you!

CHAPTER 40

Stop Giving Everything Away for Free

I encounter far too many entrepreneurs who undervalue themselves, their art, their products, and their services. Are you one of them? Please, stop giving everything away for free! If you believe your products and services are truly the best solution for your customers, they can and should pay you top dollar for them. Here are things I rarely, if ever, give away for free.

Money Wellness Classes. Ironically, I am doing one of these for free later this month. It's the first unpaid class I've taught in two years. Why am I doing it? The audience will be made up of 15 to 20 small business owners with variable income—my ideal coaching clients. My goal is to secure at least 3 to 5 of them as clients, which is worth several thousand dollars to my business, not counting any future referrals. If you're going to give up several hours of your time to do something free, there should be a serious potential upside. For example, a musician might choose to do a free gig because he knows there will be other venue owners and managers in the audience who might hire his band for future gigs.

Speaking Engagements. I am very picky about the unpaid speaking engagements I do. When someone approaches me with an opportunity, I will tell them my usual speaking rates,

assuming they are going to pay me. Surprisingly, many of them do. Sometimes, we negotiate the fees down a bit to fit their budget if it is a non-profit or educational institution. I recently shocked one of my colleagues by telling him I was being paid by a local library for a speaking engagement. "They never pay me!" he exclaimed. If you assume an organization isn't going to pay you, then they won't.

Financial Coaching. Financial Coaching is the bread and butter of my business. Since starting my business, I have only given away a handful of coaching sessions, including one to a widow and one to a dear friend who found herself suddenly on her own and on the way to divorce court. I also do *not* give away a free initial consultation, as many coaches and consultants do. Instead, I regularly do 15-minute "Coffee Chats" via phone or video to explain the coaching process so potential clients can decide if it's a good fit for their situation. I also offer a 100% money back guarantee. If someone feels like the coaching session was unsatisfactory, they don't have to pay me for it. In all my years of coaching, I've only had one person take me up on this. If you're going to offer a free consultation, ensure it's just long enough for both you and the other person to determine if you want to work together, but not so long that you fix their problems and don't need to come back for the second or third or fourth paid appointment!

Now, notice I didn't say, *never* give anything away for free. The things I do give away for free usually are not expensive or time consuming. For example, I frequently give away my e-books as bonuses or incentives for customers or potential clients. This costs nothing but gains me goodwill, because the other person appreciates the free gift. Additionally, I offer free content on my website in the form of videos, blogs, and podcasts which offer solutions to a plethora of money problems. This content not only helps others, but it builds my brand and reputation as a subject matter expert in my field.

Anthony Jordan, C.E.O & Founder of Invito Personal Chef, agrees it pays to be choosy when giving away your time, expertise, or products. "I volunteer strategically for exposure. If I'm doing a cooking demo, I want to make sure that plenty of

potential clients will see me and taste my food." It's a wise business practice to consider how your freebie will eventually drive real dollars to your door.

I do think it's a wonderful idea donate a portion of your time and products to worthy causes that speak to your heart. When I teach free money wellness classes, it's usually for organizations who are assisting people to break the cycle of poverty or addiction. I donate my time and books to people who need a "hand up" and couldn't afford to hire me. If you're an artist, you may decide to donate a painting to a charity auction, or occasionally conduct a free class at the local senior center.

Here's the bottom line: donate to worthy people and causes, not to your customers who are willing and able to pay full price. If you are giving a freebie or discounting your products for someone, *tell* them you're doing it and the dollar value they're receiving.

CREATIVE MONEY EXPLORATION

How will you decide when and what to give away for free going forward?

CHAPTER 41

Ask for the Money You Deserve

Why do so many creative entrepreneurs and small business owners—me included—have problems asking for the money they deserve? In part, I think it's due to some measure of self-doubt. "Am I charging too much?" "Did I give enough product or service to warrant that price?" "What if I raise my prices and lose customers?"

Here's one thing I have learned: if I don't think my products and services are worth the prices I charge, my clients won't think so either. How do you know if you are charging what you're worth? One way to do this is to shop around with your competition. Ask other people in your line of work how much they charge. If they won't tell you, have a friend or family member play "spy" for you and see what your competition's charging. If your prices are more than 10% below the average of your competitors, it's time to raise your prices. Of course, this isn't always cut and dry when we're dealing with art and creative services that are uniquely packaged. However, you should be able to look at someone with a business similar to yours to at least determine if you're undercharging.

Here's another clear sign you need to bump up your prices: if you've had people tell you that your prices are too low. Believe them! I've raised my rates for coaching, classes, and online courses for the last three years in a row and am busier now than I've ever been. Guess what? I'm probably going to raise them

again. You can raise prices across the board, or just raise prices for new customers. The other option is to immediately raise prices for new buyers (since they have no knowledge as to what you were charging), then step up pricing for current customers over a period of time.

Sometimes, you need to ask for more favorable terms such as down payments, progress payments, or shorter payment turnaround. I now require down payments to hold dates for coaching sessions, money wellness classes, and speaking engagements. I was nervous about instituting this policy, but none of my clients have objected! I understand that when you're working with large corporations, you may have to take their terms to do business with them, and that's a decision you'll have to make. But in this day and age of PayPal and Square, you can ask for (and receive) instantaneous payment from your customers.

Do you need to increase your prices or change your payment terms? It's time to ask for the money you deserve!

CREATIVE MONEY EXPLORATION

Play private investigator and spy on your competition to ensure you're not short-changing yourself.

CHAPTER 42

The Power of Focus

As a self-employed creative, it's easy to fall into the trap taking any paying business opportunity that comes along. Your paycheck is 100% your responsibility, and you have to do whatever it takes to make ends meet, especially in the beginning. However, when your focus is scattered, it hurts your business in the long run. I know because it happened to me.

When I left my corporate job in 2012 to do financial lifeguarding full-time, I admit that I was clueless about what it would take to build my business. I began taking on projects that really had nothing to do with my purpose of helping people rescue their financial dignity through coaching, speaking, and writing. I mentioned earlier in this book that I managed social media accounts for six customers, I did bookkeeping work for two companies, I wrote advertising copy for brochures and websites, and I joined a network marketing cosmetic company. The biggest mistake I made was telling people that I could help them with financial coaching, social media, bookkeeping, sales copy, and oh yeah, sell them a tube of cruelty-free, non-toxic mascara! No wonder people were confused about my business!

About 18 months into my journey of self-employment, I sought out help from Success Coach, Nanette Polito. I confessed to Nanette that I felt scattered and knew I needed to focus, but I was scared that I wouldn't make enough money if I limited myself. The first thing she had me do was stop talking publicly

about the things that weren't connected to my core business of being the Financial Lifeguard.

Nanette advised me to focus my sales and marketing activities on financial coaching and money wellness classes for employers. She taught me about the bullseye principle of marketing. Although it sounds counterintuitive, when you talk about your business and your ideal client, you should be as specific as possible because it will bring you more of your best customers. That doesn't necessarily mean you should turn down buyers who don't fit that perfect bullseye; that's up to you.

Shortly after starting my business coaching with Nanette, I began releasing my unrelated streams of income one by one. I stopped managing social media for anyone but myself. I quit the direct sales company. I stopped advertising my editing and copy writing services. But the scariest focus leap I made was in the spring of 2017. I gave up my largest bookkeeping client, KRC Machine Tool Services, my family's business. When I resigned as an employee in 2012, my Dad asked me to consider doing the month-end accounting as a subcontractor and I agreed. I began spending one week every month at KRC doing bookkeeping work, which paid me about $24,000 annually. This was a nice cushion that I could count on. However, it also was consuming 25% of my productive time which could have been spent building my business as the Financial Lifeguard. It was like I had one foot in each of two boats: the family business boat and the Financial Lifeguard boat. If I didn't take my foot out of the KRC boat, I would always be pulled along in its wake. The Financial Lifeguard boat would never go where I wanted it to. So, I finally let that last unrelated stream of income go. And it was the most terrifying thing I have ever done in my business.

Then something interesting happened. Shortly after I let that piece of business go, new opportunities that were right in line with my mission began flowing my way. Corporate clients I'd been trying to do business with for over a year began calling me and booking Money Wellness classes for their employees. People I had met only once would want to get together for coffee or a conference call to talk about my financial coaching packages. New ideas for financial writing projects, like this

book, came pouring in almost faster than I could write them down. Why is that? *Because what you focus on expands.*

Yes, you may need to work side gigs while your business is taking off. If you're a fashion photographer, you may need to take on some wedding clients while you're building your fashion portfolio. That's okay, just don't advertise that you're a wedding photographer; otherwise, you'll get more of the work that you don't want! If you are a musician, you may choose to bartend for a little while until things take off. But make sure you are ultimately focusing on your core business and telling people about that, not your side gigs. And sometimes you do need to let go of that work *before* you feel like you're ready in order to open up space and time to focus on your core business. If you do need to open up additional streams of income, focus on ones that closely support your creative business mission.

CREATIVE MONEY EXPLORATION

Are you doing things that are diluting your focus in your business? If so, write them down along with the associated income you receive from those activities. If you're not making any money from them, stop doing them now. If you are making income from them, brainstorm new streams of revenue in your core business that could replace them.

PART SIX

Look Like a Pro, Act Like a Pro

CHAPTER 43

Your Professional Appearance

Your professional appearance directly affects your income. I know, we shouldn't judge a book by its cover, but the truth is that we do! People will judge your business by you, your website, and your marketing materials. The Harvard Study of Communications found that it only takes seven seconds to make a first impression. What's interesting is that 38% of what makes up a first impression is how you sound, 7% is the actual words you say. This means that 55% of a first impression is visual. One final tidbit from the Harvard Study of Communications: it takes meeting the same person *seven additional times* to change the original impression you made on them. If your first impression with a new potential customer isn't stellar, chances are you're *not* going to get seven opportunities to change that. Let's make sure the outside is an accurate representation of how amazing you are on the inside, so that shines through the *first* time you meet people.

You are a walking billboard for your business. And because you're self-employed, you are never really "off the clock" as your company's representative. No, I'm not advocating that musicians and fiction writers wear three-piece suits. However, when you're among potential buyers, you should be well dressed for your profession. For the tattoo artist, that may mean jeans and a t-shirt, but let's make sure the t-shirt isn't stained or wrinkled. Your style can and should reflect your artistic nature.

Use your love of color to put together quirky, yet tidy, outfits that suit you. My friend, Jill Morenz, an interior decorator, loves to dress creatively because, "Why would someone trust me to put a room together for them if I can't put together an outfit?" Take a look at yourself in the mirror and pretend you are one of your dream customers. Would you hire yourself based on a first impression?

In a recent conversation with my speaking coach, Kay Fittes of High-Heeled Success, LLC., she confided she once had a client who was attempting to market her services to executive-level women. However, this woman dressed in cheap, ill-fitting clothing, severely distracting from her professional image. Needless to say, it was hurting her bottom line. Several years ago, I hired an image consultant to assist me with figuring out what types of clothing and colors were flattering for me. It's one of the best investments I made in myself and my business, because it continues to pay me dividends to this day.

Don't forget to look beyond clothing to your accessories, including jewelry, purses, laptop bags, shoes, and wallet. If you're dressed professionally, but have a ratty-looking laptop bag, that can detract from your image. Here's the bonus of dressing sharp: it infuses you with confidence. When I have an important presentation or client meeting, I wear something that makes me feel like a million bucks. That feeling comes across in your voice and body language.

I'm always running into customers and business contacts at church, the grocery store, and local restaurants. This is why I do my best to look put together even if I'm casually dressed. I'm not saying you can never relax or wear sweatpants. My work-from-home uniform is just that: hoodie and sweatpants. But if I'm going out in public (yes, even Wal-Mart), my goal is to still look polished even if I'm wearing jeans and sneakers. Unless you are in the process of throwing a clay pot or painting a mural, your clothes shouldn't be stained or wrinkled. And you don't have to spend a million bucks to look like a million bucks! I love shopping at discount stores, outlet malls, and consignment shops. You can find great looking pieces that won't bust your budget. No one will know that you only spent $40 on that Calvin

Klein dress or $20 on that Tommy Hilfiger dress shirt unless you tell them. (And you shouldn't.)

Pay attention to the details of your personal grooming, too. You don't need to spend two hours applying contour makeup or grooming your handlebar mustache, but you do need to put some effort into your appearance beyond your clothes. If you have chipped polish or dirt under your fingernails, people will notice. Unless bedhead or an unruly lumberjack beard are a part of your branding, make sure the hair on your head (and face) is clean and has some semblance of style. There's no need to spend a fortune on personal grooming, but you either need to do it yourself or make an appointment with a hairstylist, barber, or manicurist. Take a cue from the financially successful people in your creative field.

If you bought space on a billboard at the busiest intersection in your town to advertise your business, you'd ensure your ad was professionally designed and visually appealing, right? Well, don't forget, you are a walking billboard for your business!

CREATIVE MONEY EXPLORATION

Make an honest appraisal of your appearance. Do you look like a successful artist, musician, photographer, business owner? What changes do you need to make to look like the success you want to be?

Being Successful Versus Looking Successful

We just discussed the importance of investing in your professional image because it is vital to put your best foot forward to attract customers to your business. However, some people take this to extremes and become overly wrapped up in the outside package. There's a huge difference in trying to look rich and successful versus *being* rich and successful. The terms successful and rich are subjective, and we can argue over exactly what they mean. I really love the definition of rich that Jen Sincero gives in her book, *You Are a Badass at Making Money*. "RICH = Able to afford all of the things and experiences required to fully experience your most authentic life."

Our current culture is obsessed with the outward appearance of wealth and success. Media fills our feeds with the latest celebrity-endorsed products that will make our lives complete. Credit card companies gladly extend our limits to buy the things that allow us to look rich, even when we're living paycheck to paycheck. Unfortunately, self-employed creatives at all income levels fall into this trap. The truth is that there's no way to tell if a person is truly financially successful by looking at them.

The other day, I interviewed two men who run entrepreneurial training programs for minorities to combat

poverty in their respective cities: Allen Woods of MORTAR and Anthony Watkins of Launch Chattanooga. We were discussing this phenomenon of people at all income levels who ruin their financial health by trying to look rich. Anthony related a story of a guy who just bought fancy rims for his car, and then had the nerve to hit him up for a loan until payday because he needed grocery money to buy his kids some milk. And don't think this only happens in the inner city or suburbs, because it's even worse at the country club!

Years ago, I worked with a guy, we'll call him "Jake," who earned a high income but had almost zero net worth. Jake looked rich. His McMansion backed up to the golf course. He drove a Cadillac Escalade, and wore designer clothes and shoes. In fact, he bought the best things money could buy. Yes, his income was high, but Jake spent the bank's money because he'd already blown through his own. Every single thing he "owned" came with a monthly payment. On more than one occasion, Jake asked for an advance on his commission so he could pay his bills. This guy was making twice my income, but likely had one-tenth my net worth! Trying to look rich can make you poor, and it wouldn't surprise me if Jake eventually ends up in bankruptcy court.

TRYING TO LOOK SUCCESSFUL VERSUS BEING SUCCESSFUL

People who are trying to look successful buy things that decrease in value. People who are successful (or want to be) buy things that increase in value or provide positive cash flow.

People who are trying to look successful get their worth from the approval of others. Financially healthy people have a strong sense of self-worth that's not dependent upon the whims and opinions of other people.

People who are trying to look successful are always living on the edge financially with little to no money in savings. The successful know that saved money will allow them to comfortably handle emergencies and seize opportunities to invest.

People who are trying to look rich and successful accumulate debt from impulse purchases and non-necessities, like vacations and designer clothes. Those who are financially wise exercise patience to save up the money and wait for the right deal.

People who are trying to look successful are "all about me." They are wrapped up in themselves and their possessions. Financially successful people have the resources to help others and support causes and charities close to their hearts.

If you can afford to pay for luxuries and not go into debt for them, then by all means, have fun and enjoy! However, if you are trying to look rich without being financially healthy (spending within your means, having adequate savings and minimal debt), you're going to end up living on the edge of broke, which is very dangerous for you and your creative business. The financial health and security of your family is of much greater importance than the opinions of others. So, ensure that you're presenting a professional image without pretending to be rich, and ruining your finances in the process.

CREATIVE MONEY EXPLORATION

What are some ways you can elevate your professional image within your budget?

CHAPTER 45

Digitally You

Your professional appearance and behavior should extend beyond your physical space to the online world of websites and social media. If you're self-employed, you represent your business 24/7/365. If you're behaving badly on your personal social media accounts, you risk tarnishing your professional reputation. The longer I'm in business, I realize that a growing number of my social media friends and followers are business contacts and potential clients.

There are times when I think about posting or commenting, then I decide to abstain because it wouldn't be a productive conversation. I'm not being "fake" or sanitized online; I'm still a sarcastic smart ass with a strong love of books, wine, cats, and mixed martial arts. I have definite opinions on politics and religion, but I don't pick fights on Facebook over them. I have coaching clients of all races, religions, sexual orientations, and political views. It wouldn't be wise on my part to alienate the very people I want to help rescue their financial dignity. Besides, even if I don't agree with someone's viewpoint, I can and do still respect them. So, unless you are a pastor or a politician, tread very carefully in these areas and keep your comments kind and respectful.

If you take to social media after a night of partying and post a rant about your ex, it might make you feel better in the moment. But it could cause your fans, friends, or family to think

twice about referring you any business, because you seem impulsive and irresponsible. Every day in the news we see a celebrity or politician ripped to shreds over an ill-worded tweet or questionable post. This happens on a smaller scale to everyday people like you and me in our social and business circles. Your goal is to make a damn good living with your creative business! In order to do that, lots of people are going to have to know who you are and what you are selling. You need to become the "celebrity" in your artistic space.

Before you post something questionable, ask yourself, "Will this detract from my professional image?" There are plenty of ways to be entertaining and hilarious without being offensive or off-putting. A good rule of thumb is this: if you wouldn't say it to someone's face, don't say it on social media. You are essentially grabbing a bullhorn and shouting whatever you post on social media in the faces of all your connections, fans, followers, and friends. Don't offend your potential customers by being vulgar or mean. Be sure you are a beacon of light rather than a spewing cesspool.

CREATIVE MONEY EXPLORATION

Pretend you are your dream customer. Go look at your social media accounts, both personal and professional. Would you hire yourself, based on what you see in your feed?

CHAPTER 46

Body Language

I t's not just how you dress that affects your professional image. Body language can vastly undermine or enhance your credibility. Slouching, crossed arms, and other closed-off body language subtly tells people (your potential customers) to go away. If you stand tall, smile, and look the person in the eye when you talk to them, you convey both confidence and welcome.

Much of our body language is habitual and subconscious, so it takes effort to positively improve it. The first step is to become aware of the body language of others and what it's telling you. Then do the same for yourself. I highly recommend reading, *What Every Body is Saying: An Ex-FBI Agent's Guide to Speed Reading People*, by Joe Navarro. It is absolutely fascinating and gives insightful suggestions for positively influencing people through your own body language.

When I began applying for jobs in high school, my dad gave me an important lesson: the proper handshake technique. Honestly, at the time, I thought it was the most ridiculous thing ever. My dad made me shake his hand over and over until I nailed it: a firm (yet not crushing) handshake, while smiling and looking him in the eye, saying, "Hello. It's so nice to meet you." For months after that initial lesson, he'd test me occasionally until he was satisfied I had it down pat. At 16, I felt annoyed at my dad every time he'd give me the handshake test. Now, I am

grateful he taught me the proper technique because it's served me well over the years. A well-executed handshake conveys confidence to the other person. A "limp fish" or "bone crusher" handshake will make you seem timid or aggressive, which is not a great first impression!

At meetings and networking events, ensure that your body language is open, friendly, and confident. If you are smiling, leaning forward, and making good eye contact, you'll be subtly drawing people towards you. If you're scowling, leaning away, or crossing your arms, you are repelling others which will cost you in a business setting. Your shyness (avoidance of eye contact and conversation) may be perceived as snobbery. People are less likely to approach you and engage in conversation if your body language is closed off.

Conversely, if your body language is on point, business contacts and potential customers will be impressed with you before you even open your mouth. Follow dad's advice for business success: Sit up straight, stand tall, smile, give a firm handshake, and look people in the eye.

CREATIVE MONEY EXPLORATION

Ask someone you trust to observe your body language for a day and then report back to you on what you could improve.

CHAPTER 47

Watch Your Words

When you're meeting with potential buyers and other business contacts, watch your words, not just your body language. If the person you're talking to isn't in your industry or field, they may not understand the technical jargon and become lost or confused. Until you gauge their understanding of your business or art, explain things as simply as possible and don't assume they know what you're talking about. If you make a potential customer feel stupid because you're talking way over his head, he'll remember how you made him *feel* more than the quality of your product or service. Many times, we do this without thinking about it, because we're constantly immersed in the jargon of our respective fields. I hate to say it, but folks in the financial field are probably some the worst offenders. Just because I know what a HELOC is, doesn't necessarily mean my client does. (FYI: It's a home equity line of credit.) This is why I make a conscious effort to speak about business and money as simply as possible.

Be cautious with your use of foul and derogatory language, especially in business settings. This isn't the bar or locker room! An off-color joke meant to entertain could diminish a potential customer's chances of hiring you. I remember listening to success guru, Jim Rohn, early in my business career and he said something very profound about the use the foul language: "If you *don't* cuss, you have a 0% chance of offending someone."

My approach is a little different. If I'm with a client or prospect and he or she lets a cuss word fly, then I know I can loosen up a bit with my language and use the same word without fear of offending. Foul language can be interpreted as unprofessional and could cost you a sale. Yes, there are some professions where cussing is the norm. If you're in a punk band or a stand-up comedian, foul language may actually gain you more business, but these are the exceptions. For the rest of us, it's best to tread lightly until you know the person well enough to relax in the language department.

When in business circles, take care when discussing controversial topics such as religion or politics. In fact, it's best to avoid those discussions in a business setting. There's no need to unnecessarily alienate a potential paying customer just because they pray or vote differently than you!

Another issue that arises when speaking with others is the excessive use of filler words. "Um," "ah," and "you know," make you sound unsure of yourself. When you listen to people who command a room, they're comfortable with pockets of silence and don't need to fill them with um's and ah's. I know a woman who holds the top position at a local non-profit agency. She's a super nice lady, but her professional image is diminished by using a ton of filler words. Like every. Other. Word. She comes across as uncertain and lacking confidence when she speaks.

How do you overcome this habit of using filler words? The first step is awareness. My father pointed out to me early in my professional career that I used "you know," as a filler phrase. I literally put a sticky note on my computer with the words "You Know" on it with a circle around it and a line drawn through it. When you start catching yourself using your filler word or phrase, you're making progress! The second step is to be okay with a little silence. Silence is powerful and actually makes you seem smarter. As the old proverb states, "Even a fool is thought wise if he is silent." A brief pause of silence between sentences appears as though you are thoughtfully considering your words, and that's a good thing!

CREATIVE MONEY EXPLORATION

Ask someone close to you to give you feedback on your language and filler words or phrases. Are these negatively impacting your professional image? If so, take steps to become more aware of your words and choose differently. Be patient with yourself because it takes time to change the habitual ways we speak.

CHAPTER 48

Be On Time

Being chronically late is *not* cute or quirky. Lateness is not a personality trait that can't be helped. In fact, showing up late for client meetings and other business engagements will cost you cold hard cash. When you cause another person to wait on you because you're running late, you're sending them this powerful message: "I don't respect you or your time." If you do this to a potential customer or referral source, you may lose business opportunities before you even walk in the door. Consciously or unconsciously, people will judge your lateness as disrespectful, lazy, sloppy, or incompetent. "If she can't even show up on time for this meeting, how can I trust her to photograph my wedding?" a potential client may surmise. I promise that if you are chronically late to business appointments, you are losing sales.

If you are habitually late to every appointment, what can you do to break this pattern? One trick I use for myself is to set an alarm that ensures I'm leaving the house ten minutes earlier than necessary. Even if I am running a tad late or encounter traffic en route to my appointment, I'm usually there five to seven minutes beforehand. This gives me time to settle in and check email or my social media feeds until the other person arrives. You could also schedule your appointments for 15 minutes before the actual start time in your phone or calendar.

Another trick is to imagine that your appointment is with one of your idols, whether it be a celebrity, politician, or religious icon you're dying to meet. Would you be late for a meeting with the Dali Lama, Oprah, or your favorite New York Times bestselling author? No way! You'd be early and bouncing up and down with excitement to meet this very important person. Guess what? Each and every person you meet with is important and their time is valuable. And you never know from where your next customer or big break is going to come. I've landed some amazing jobs and connections through the least likely people. Being late is a subtle form of self-sabotage, so it's important to rid yourself of this nasty habit.

CREATIVE MONEY EXPLORATION

Are you usually early, on time, or late for appointments? If you are chronically late, which of the suggestions in this chapter are you going to implement?

CHAPTER 49

Where the Magic Happens

Depending on your art and business, you might need a dedicated place to create and conduct business outside of your home. Writers, graphic artists, and photographers could easily work out of libraries, coffee shops, or their spare bedrooms. But this doesn't necessarily work for all creative entrepreneurs. Some artists require more physical space for painting large canvases or creating metal sculptures. Other artistic endeavors require a very particular type of space, as in a musician's recording studio.

When evaluating your creation space, you need to consider balancing three things: cost, ease of use, and professionalism. Of course, free space to conduct your business is wonderful, especially when you're in the start-up stage. Many a creative entrepreneur has launched a business from a kitchen table, garage, basement, or a home office—including me! However, if your free space isn't conducive to you creating art because your kids are constantly intruding or your attention-seeking cat keeps knocking over your cups of paint, it may be costing you money in the form of lost productivity. If your potential customers are meeting with you at your free space, and it's not professional, that could detract from your professional image and be costing you sales.

I started my business over six years ago, out of my home office (spare bedroom). For a long time, I didn't really need a

dedicated office space. Books and blog posts can be written from pretty much anywhere. When I contract with a company for my Money Wellness classes, I go to my customer's location. I frequently coach clients around the country via phone and video chat. However, an issue arose when a local client wanted me to coach them in person, which I really love to do. Many times, I didn't know the person or couple well enough to feel comfortable coaching them at my home office.

My solution for five years was to use my free option: the conference room at my family's business, KRC Machine Tool Services. Most of my coaching appointments are in the evenings or on weekends, so the conference room was available for me to use. Although the conference room area itself was very professional, many of my clients were perplexed. *Why was my office in an industrial park? What is this place? What does KRC stand for?* Then I would have to explain to them that KRC is my family's business that I used to work for, but they still let me use the conference room for free. Can you see how this might tarnish my professional image with brand new coaching clients? Especially when my ideal clients are high income earners? I decided my free option made me look like an amateur, so I explored other avenues that I'll cover in a minute.

It's perfectly fine to use free or inexpensive space for your business, as long as it's not repelling potential paying customers. On the flip side, I don't want you overpaying for your space either. There's plenty of expensive commercial real estate you could rent or purchase, some of which may be overkill. Depending on your target customer base, an over-the-top fancy office may deter them from doing business with you, because the environment feels intimidating rather than welcoming.

Besides price, you need to consider ease of use. You want your business space to promote maximum creativity and productivity for you. Here are some things to consider:

- If you're renting space, can you come and go as you please?
- Will you be able to access the space on evenings and weekends if necessary?

- Is there room for your creative materials?
- Is the environment conducive to your creativity or are there distractions? (If you're looking for quiet space to write, an office right next to the fire station probably isn't a wise choice.)

Your space needs to be a professional representation of you and your business. This is going to be unique to your art and your ideal target customer base. The space where I meet my clients for financial coaching is going to be very different from the tattoo artist's shop, as it should be. The question to ask yourself when considering space is this: Will this space enhance or detract from my professional image as a (fill in the blank)?

If you have usable, professional space to set up a home office or studio, that's great. Just keep in mind that some of your customers may not be comfortable meeting you at your home. If you have pets, a buyer might be scared of dogs or allergic to cats. The other thing to keep in mind with a home office or studio, is that you're essentially inviting strangers (potential customers you may not know very well) into your house. It's important to use some common sense and protect your personal safety. Meeting potential clients at a coffee shop, their office, or other public place may be perfectly acceptable if you are an editor, website designer, or makeup artist.

For many self-employed creatives, renting space is the best balance of price and professionalism. With the rise in entrepreneurship, work space options are springing up outside of the traditional model. Shared office and studio space rented as a subscription is rising in popularity. In fact, it's the option I've chosen. Whether you share space with other self-employed creatives formally or informally, it can keep your costs down, especially if you don't use the space 40-plus hours a week. Coworking spaces are popping up all over the country with amenities that include phone, mail, and receptionist services, plus a bank of hours for the use of private office space and meeting rooms. You're typically paying month-to-month with a 30 or 60-day cancellation notice, meaning you're not locked into a long contract.

I am currently a member of Platform 53, a coworking space located a mile south of downtown Cincinnati. The founder, Stacy Kessler, wants to provide solo entrepreneurs with a productive and creative space where they could not only work, but also collaborate and find community with other business owners. Their motto is: "Work solo, not so lonely." (Love that!) The historic building has an artsy vibe that's cool and casual, yet professional. Like other coworking spaces, Platform 53 offers several packages to choose from, which include common work space, private offices, and meeting rooms. They also host community building events like happy hours and professional education events for members. Coworking spaces are affordable places to work and ensure you aren't isolated.

The benefits for me are that my fixed monthly cost is lower than outright renting an office, and I'm not locked into a long contract. I don't have to worry about utilities, cleaning, or maintenance. If I had my "own office," I'd either have to hire a cleaning service or clean the toilets myself (no thank you)! This coworking concept has branched off from your typical office and conference spaces to art studios, workshops, recording studios, and other creative coworking spaces. I'm amazed at the options available for creative entrepreneurs here in my city. Do a quick internet search for shared office space or creative coworking space near you and explore your options.

Your creative business may outgrow your home studio and even coworking spaces. You might be at the point right now of considering dedicated space that is yours alone. It may be exactly what you need to take your creative career to the next level. I highly recommend that you involve your accountant and CPA in the evaluation of renting or buying real estate to determine the financial impact on your business. When considering a long-term lease or commercial real estate purchase, don't just look at the monthly payment. You may also need to pay for insurance, utilities, repairs, lawn and parking lot maintenance, and cleaning.

When should you rent dedicated space for your creative business? If you are turning away orders from paying customers because of space constraints, this may indeed be the right move

for you. Maybe you suspect that you're losing potential buyers because your home office or studio makes you appear as an amateur, rather than a professional business owner. Investigate multiple space options and bring along your pickiest friend or family member to tour the spaces with you. He or she will point out all the possible issues, which will give you leverage in negotiating a contract. This person will also prevent you from falling hopelessly in love with a space because of its mid-century modern details, while overlooking the proximity to the train tracks and the water stain on the ceiling. *Always* pay an attorney who specializes in real estate to review rental or lease contracts before signing. A few hundred dollars paid to a lawyer could reveal a lease clause with the potential to cost you thousands of dollars because you didn't understand it. Be mindful of the length of the lease. Who knows how your business will grow (or shrink) over the next two to three years. You don't want to be stuck in a space that no longer fits you.

I interviewed one painter who rented a studio space without crunching the numbers. She realized after a few months that she wasn't bringing in enough money selling her art to pay for the studio. So, she decided to start teaching painting classes to cover the rent. The problem? The painting classes consumed so much of her time that she wasn't creating her own art, which was the whole reason she wanted a studio in the first place! At the end of her 1-year lease, the artist went back to painting from home, which ended up being less stressful and more enjoyable.

When to purchase real estate for your creative business is a complicated decision that should *not* be rushed into. It's important to be working with a knowledgeable commercial real estate agent who has been in the business for a good number of years. Your accountant, CPA, and attorney should also be consulted during this decision-making process. Your accountant or CPA will help you crunch the numbers to ensure you can afford to own commercial real estate and will also explain the tax consequences. You must make sure that the property is zoned for your type of business. Your commercial building payment will likely be a 20-plus year commitment. What if you decide that entrepreneurship is not for you in five years? Then

you'll be stuck with trying to sell it or become a landlord, which is a responsibility you may not want.

Just as with home ownership, commercial real estate comes with extra expenditures beyond the monthly payment: property taxes, maintenance on big ticket items like roofs and parking lots, furnishings, and property insurance coverage. Owning a building also locks you into a location for a long period of time. What if your spouse receives an amazing job offer in another state? Buying real estate—and even leasing it—is a complicated decision, so don't rush into it and make sure you receive wise counsel from the appropriate people before committing.

CREATIVE MONEY EXPLORATION

Is your place of business conducive to your productivity and enhancing your professional appearance? If not, decide if a change in location is in order. If you can't afford to rent space or cowork yet, how much more a month would you need to earn in order to make that happen?

CHAPTER 50

Small and Mighty Marketing

Your smallest piece of marketing material has the potential to be the mightiest force for bringing in business, *if you do it right.* I'm talking about your business card. Although it's just a few square inches of real estate, chances are excellent you hand out your business card more often than any of your other marketing materials.

In addition to your smile and handshake, your business card is one of the first impressions you leave with new potential clients and contacts. Make sure it is a good one! I've been handed more poorly designed business cards than I care to admit, and it always makes me cringe internally. A flimsy, hard to read, or mediocre business card causes us to overlook someone who is otherwise a very talented individual. How do you ensure your business card is a brilliant representation of your professionalism? Here are some tips to make your business cards mighty marketing machines.

Be creative, but not *too* creative with your design. Yes, I know as a creative, it's tempting to showcase your design talent to ensure your calling card is super cool. However, this a business card, not necessarily a sample of your artwork. It needs to have all of the basics in a font that is easily readable: full name, phone number, email address, and website. I'm not saying you can't be creative with your business card, but when the

design eclipses the true purpose of the card (to allow potential customers to contact you), that's a problem.

Select a substantial card stock. Don't go with the cheapest, flimsiest cards you can buy. And please don't print them yourself from your home computer. This screams "amateur!" You can purchase a high-quality business card from websites such as VistaPrint.com or at your local UPS Store at a very reasonable price.

Design for readability. I recently received a business card from a professional that had black lettering on top of a dark picture. I could barely read his contact info! Plus, the picture had nothing to do with his business! It pictured his house in the country, which left me feeling confused. Choose a contrasting color so the font stands out from the background. Don't try to fit too much text on your business card. If you do, you'll have to select a very small font, leaving those of us in the over 40 set squinting at your card. If you want more room for information, try choosing an unconventional business card size or shape. I've seen cool business cards in the shape of a sporting event ticket or a larger square size versus the standard small rectangle.

Include your head shot. Did you know that your business card is 70% more likely to end up in the trash if your picture is *not* on it? It's true! If your picture is on your business card, the person feels like they are throwing you in the trash! Plus, your picture links your face with your name and your potential customer is more likely to remember you later. Invest in a professional head shot to ensure you're leaving a good impression. A bad picture can be worse than none at all. And if your head shot is more than ten years old, for the love of God, go get a current one. Update your picture every few years so it looks like you now.

CREATIVE MONEY EXPLORATION

Not sure if your business card measures up? Ask a few trusted colleagues their opinion on how you could improve your smallest, and potentially mightiest, piece of marketing material.

CHAPTER 51

How to Get Free Press

I had a crash course in Public Relations (PR) with the launch of my first book, *Money is Emotional: Prevent Your Heart from Hijacking Your Wallet*. In the course of one week, I appeared on three different local TV stations, one radio show, and two podcasts. It was fun, nerve-racking, and a little exhausting. As a creative entrepreneur, I don't have a huge budget for advertising, which is why PR is an important part of my brand awareness strategy. As sales guru Grant Cardone says, "Your biggest problem is obscurity." If people don't know about you, they can't buy from you. Let's talk about what exactly PR is, what it can do for you (and what it can't), and how to get yourself some of it.

Public Relations is managing the spread of information and fostering goodwill between an individual or business and the public. PR exposure typically costs little to no money, which is why small businesses and entrepreneurs should be utilizing it. PR requires time and effort because you'll need to contact writers, editors, and producers with your pitch to cover your story. Don't miss the "story" part: that's vitally important! Magazines, blogs, podcasts, and TV news outlets are always in search of a good story to cover. It's not enough to be a creative business owner selling a product or service. There has to be an intriguing story about you, your business, or your art before media outlets will feature you. What are you doing that's

newsworthy? If the answer is "nothing," your efforts to pursue PR will be wasted.

WHAT PR CAN DO FOR YOU

- Generate awareness for you, your brand, and your art. Ongoing PR activities will keep you at the forefront of your customers' awareness.
- Increase your following on social media and grow your email list.
- Showcase you as a subject matter expert in your field. Media outlets may then view you as a credible source and come to you later for your take on current events in your field of expertise.
- Raise your profile with current and potential customers, fans, and followers.

WHAT PR CAN'T DO FOR YOU

- Replace your sales and marketing activities. You may gain a few customers from PR activities, but you'll mostly gain interest and awareness, not sales. You'll need to follow up with these new contacts and fans via your normal sales and marketing channels.
- Make you into something you're not. If people tell you that your products or services are the "best kept secret," PR can rectify that situation. But if your products and services are mediocre, PR will only hasten your demise.

Once you've decided you want to capitalize on PR activities, how do you get noticed? Sure, we'd all love to be a guest on the Steve Harvey show (No? Maybe that's just me!) or be interviewed by a national media outlet. However, most creative entrepreneurs start out with smaller, local media coverage before the big guys will ever look their way. The great news is that it is

relatively easy to get local PR coverage for your business and projects from a variety of sources.

Before I published my first book, I crafted a PR plan and I suggest you do the same for your star projects. I listed all of the local media outlets I wanted coverage from and began asking friends, family, and my business contacts for connections. One woman on my Dream Team of early readers grew up down the street from one of the local TV anchors. A Cross Fit gym owner I know connected me with another TV anchor who works out at his facility. Both were able to facilitate email introductions for me, which resulted in my appearing on three of the four local news channels during the launch week of my book. If you reach out to a producer or a reporter when someone has made a personal introduction, you've got a much greater likelihood of success.

The first thing you need, even before you start connecting with the media is a well-written press release. If you're not a writer, please pay someone to do this for you! If your press release has misspellings, typos, or is poorly written, you may be dismissed no matter how newsworthy your story or creative project.

Here are sources of PR coverage to consider:

- Chamber of Commerce newsletters, trade magazines, neighborhood, city, or county newspapers, and regional business or art magazines
- Your high school or college alumni newsletter or website
- Local TV stations
- Local radio shows
- Internet radio shows or podcasts, especially in related areas of interest. For example, I was interviewed on *Your Money, Your Wealth*, a radio show in the Los Angeles area that covers all aspects of personal finance and investing. Most of these radio and podcast interviews are done via

phone, so don't limit yourself to local media coverage.

- Seek out speaking engagements at networking meetings, Chamber events, charity or non-profit groups, Toastmasters, and even church groups (if appropriate).

How do you find the decision makers to line up these interviews, articles, and speaking engagements? If you can't get a personal introduction via a friend, business connection, or family member, search LinkedIn for the appropriate person. For example, I searched for the local TV producers so I could message them directly with my press release instead of sending it to the general email address for the station. Most of these professionals don't get nearly as many LinkedIn messages as they do emails, so your information is more likely to be noticed.

You can also secure the services of a local PR rep who already has connections. I hired a PR person in the Cincinnati area to help me get the word out. She got my press release printed verbatim on Cincinnati.com and secured me a speaking engagement with close to 100 business professionals where I sold my books after the presentation. A good local PR rep should be reasonably priced and clearly explain their process and the results you can expect. Some of them will write a press release for you!

After your interviews are complete, follow up with a handwritten thank you card to each reporter and producer. Hardly anyone does this anymore, so you'll be remembered. I went a step further and dropped off signed copies of my book to all three producers and all three reporters a week after my interviews. This will help keep you top of mind when the station needs a source to quote or interview in your field of expertise.

Just a word of warning: a TV appearance probably won't bring a huge influx of sales. Honestly, I was deeply disappointed that my book sales didn't spike after appearing on three morning news programs. But there is an upside, and that is brand awareness and social proof. You can now put on your website that you've been seen on ABC, NBC, the XYZ podcast, etc.

After your media appearances, ask for the video or audio files so you can embed those on your website, possibly even creating a dedicated media page.

CREATIVE MONEY EXPLORATION

Have you done something noteworthy in your business lately? If so, write a press release and send it to media outlets that might report on it.

CHAPTER 52

Tips for Stellar Interviews

Interviews in any format are an excellent source of PR for you and your business, so long as your performance is not a flop! During the course of two weeks, I was interviewed six times: three times on TV, on two separate podcasts, and one radio show when I published *Money is Emotional: Prevent Your Heart from Hijacking Your Wallet.* I learned quickly what made for a stellar interview and what didn't work so well.

Fortunately, I hired my first speaking coach a month before my book's release date. After each interview, I called her from the car, and she gave me immediate feedback on what I did well and tips for improving my next one. Here are some insights for making the most of your next interview.

"Know the story of your business inside and out—the origin, what's unique about it, and why you're passionate about it," says Kyla Woods, former news reporter and founder of Crowd or Camera Communications Consulting. News outlets want to cover interesting people with unique stories!

Prepare talking points or questions for your interviewer and email them over a few days beforehand, along with your bio. This will increase the likelihood that the interviewer will ask you the questions you want to answer on the record.

Bring a copy of your talking points or questions to the interview with you! Sometimes the person interviewing you may change at the last minute due to an illness or a schedule change.

Practice answering your questions. Think of multiple variations of the question that the interviewer might ask. Several of my interviewers went off script and asked questions that weren't on my list or asked them in a slightly different way. These reporters weren't doing it to throw me off my game. They were genuinely interested in what I had to say and put their own personal spin on the questions.

If your interview is on television or video, send high resolution pictures of your head shot, logo, or products ahead of time. If you don't, the station may pull random pictures from your website that wouldn't be your first choice of images.

On the day of the interview, wear something that makes you feel like a million bucks, even if your interview is audio only. If you look good, you feel confident, and that comes through in your voice and body language.

"Some radio shows also record video clips of the show, so dress well for these interviews, too!" advises Woods.

Speaking of body language, make sure that yours is relaxed and confident. Make appropriate hand gestures. Try not to fidget or play with your hair. My mistake with body language was being a little too stiff, especially during my first interview. I was nervous and the power pack for the microphone was poking me in the back, so I was sitting forward at an awkward angel. In contrast, I was more relaxed and confident at my last interview, and it definitely shone through!

Smile! Look at the reporter, but also glance out at the camera. If you're not sure when to do this, take your cue from your interviewer. When the reporter turns to look at the camera, follow suit with a smile on your face! (If you watch my first interview, you'll pretty much only see the side of my face. I don't think I looked at the camera once!)

"The better you perform in your interviews, the more likely you are to be asked back," says Kyla Woods. "Establish yourself as the expert they can depend on, and the media will call on you again and again."

CREATIVE MONEY EXPLORATION

Stage a mock interview and record it on video. Have a friend ask you questions while you answer. Play back the video and discuss what could be tweaked to improve your delivery.

CHAPTER 53

Help a Reporter, Help Yourself

What if I told you there's a simple way to be quoted in print and online media on a regular basis? There's a website that connects reporters to potential expert sources—YOU—and it's free! It's HARO®, which stands for "Help a Reporter Out." Here's how it works: sign up for an account as a source and select the topics that best describe your business experience. For me, it's the "Business & Finance" category. Monday through Friday, you receive three emails a day with requests for sources to be quoted. Yes, I know it seems like overload to your already overcrowded email in-box; however, I've found it's worth the hassle.

I have a process I follow for screening the HARO® emails and replying to the ones in which I'm interested.

When I've time to kill (in between appointments, waiting in line at the grocery store, etc.), I scan the HARO® emails for topics in my wheelhouse. If there are none, I delete the email.

When one catches my eye, I click on it to jump to the detailed description of the quote request. If I'm able to give the reporter meaningful input on the topic BEFORE their specified deadline, I flag the email so I can respond when I'm back on my laptop.

I respond to the reporter's questions and send the email by their deadline. I make sure to include all my contact info so the reporter can call me with questions. My goal is to respond to at

least one or two of these emails per week. This usually gets me published at least once every 6 to 8 weeks online.

The reporter typically responds to let me know if they are going to quote me in an article or blog post. Many times, they will come back with additional questions for me to answer.

Sometimes the reporter will send me the link to the article that I'm quoted in once it's published so I can share it. But sometimes they don't, which is why I set up a Google Alert for my name. This way, I'm notified via email by Google when an online article is quoting me.

I have a file where I save these links for articles, so I can share them on social media and link them to my website. It lends credence to your business to be able to say that you were a source for articles on national websites, like the recent article I was quoted in for CBSNews.com about the best way to manage your credit card debt.

Most of the time these reporters are looking for input for online and print articles, but sometimes you'll run across individuals who want to quote you in their books. I've been interviewed by two individuals regarding my experience with self-publishing for their books, one of which centers on why financial professionals should write a book to raise their credibility and profit potential. Jean Chatzky's assistant interviewed me multiple times for Jean's forthcoming book about women and money. (In case you don't know, Jean Chatzky is NBC TODAY's financial editor, an award-winning personal finance journalist, and a best-selling author.)

Yes, it does require a little bit or time and effort to screen the HARO® emails and reply to the reporters. However, being a quoted source has the potential to keep your name in the spotlight on an ongoing basis long after your book launch, ribbon cutting, or award-winning speech. It tends to impress potential customers who Google your name or business and see that you're quoted by national websites. By helping out a reporter, you help yourself and that's what I call a win-win situation!

CREATIVE MONEY EXPLORATION

If you'd like to be quoted in the media on a regular basis, sign up to be a potential source with HARO® at Helpareporter.com

PART SEVEN

Living the Boss Life

CHAPTER 54

Your Inner Circle

"Plans go wrong for lack of advice; many advisers bring success." ~ King Solomon

King Solomon is considered to be one of the wisest men to ever walk the face of the earth. If he thought it was a good idea to have advisers, maybe we ought to pay attention. When I'm coaching a small business owner or creative entrepreneur, one of the first questions I ask them is, "Who's part of your business inner circle?" If the only people you can turn to for financial and business advice are your other starving artist friends, you've got a problem! Think of your business inner circle as a Board of Directors. We think only huge corporations need a board of directors, but you must have one if you are going to financially succeed in business.

Tamia Stinson, the founder of Tether, a community and talent agency for creative image-makers says, "I see so many creative entrepreneurs who have a hair and makeup team, but they don't have a money team." Creatives are masters of their art, whether it be carpentry, writing children's books, painting, or interior design. However, most are not experts in running a business. Whether you call this group of advisors your board of directors, inner circle, or money team isn't important. The fact that you should have one is clear.

Who should be a part of your business inner circle? A combination of the following:

Your spouse, or a financially responsible friend or family member. This person should know your weaknesses and strengths and be able to give you honest feedback and help you uncover your blind spots. It's important to be open and honest with your spouse about the state of your business affairs because it directly affects their personal finances as well as yours. "The financial ups and downs of entrepreneurship can put a strain on an otherwise strong relationship," says Monica Tuck, owner of Unbridled Studios. "It's important to involve your spouse in the launch of your business and to discuss expectations, so there isn't resentment between partners."

CPA, Accountant or Bookkeeper. Even though I am a Financial Lifeguard and a natural numbers person, I still have a CPA in my inner circle. Why? Because keeping up with tax law changes is a full-time job! My CPA definitely saves me more money than I pay him.

Lawyer. It will cost you less to consult with an attorney upfront when you are entering into partnerships, leasing agreements, and other contracts than it will on the back end if something goes wrong. A good attorney helps spot things in a contract which may not be in your long-term best interest financially. They will also help you put together a will or estate plan so your loved ones can continue to benefit from your artistic creations when you're gone. Don't think this is important? When iconic musician Prince died without a will, the state had to step in and divide up his assets. This means Prince's family members may or may not have received what he intended and the court could delay the release of those assets by months and even years. It's best to do this now, even before you reach rock star status.

Coaches. Whether a business coach, sales coach, or financial coach, an exceptional one will shine light on areas you can improve and devise a plan to help you overcome them. An effective business coach gives you an ROI (return on investment) of five to seven times their fee, provided you implement their guidance. This means you should experience a

tangible increase in your income/decrease in your operating costs by applying their advice.

Other Successful Business Owners. Entrepreneurs and small business owners in other fields are full of creative ideas and advice. Some of my best "a-ha!" moments come during conversations over coffee with other business professionals. Be sure to have at least two in your inner circle.

Keep in mind that you don't have to formally ask these people, "Will you be in my inner circle or on my Money Team?" Just be sure to meet with them on a regular basis to ensure you are on track with the various parts of your business and value their advice and contribution.

CREATIVE MONEY EXPLORATION

Who is on your Money Team? Which spots are vacant and need to be filled? Who would be ideal candidates for these spots?

CHAPTER 55

Entrepreneurship Is a Team Sport

Those of us who are solopreneurs, know that being self-employed can be a lonely business at times. When you work for a company, you're typically surrounded by a team of people who are working towards common goals. We hear people refer to a coworker as part of their "work tribe," their "office bestie," or even their "work wife." Coworkers can be like one big, happy—albeit a little dysfunctional—family. But just because you work *for yourself* doesn't mean you need to work *by yourself*. In fact, you shouldn't.

If you want to succeed in your business, you need to understand that entrepreneurship is a team sport, not a solo endeavor. You need the community of other business owners for support, advice, and, yes—friendship. Whether you are a voice-over artist, intuitive coach, editor, or the owner of a retail store, you need a community of other entrepreneurs to succeed. Why?

First of all, you don't know what you don't know. As a small business owner, you are very skilled at your craft, whether it is baking the perfect wedding cake or inking a badass tattoo. However, there are so many details that go into running a successful business you may know nothing about. And that's okay, as long as you admit what you don't know and either educate yourself or pay someone to help you. Your community of creative entrepreneurs can refer you to professionals for help

with accounting, marketing, or legal issues. Some of these people may end up in your inner circle.

Second, you need resources. The easiest way to build your pool of resources is to collaborate with other business owners. In my personal experience, entrepreneurs really do love to help each other by giving advice, sharing stories, and pointing out useful tools and resources. If you're not already out there networking and socializing with other business owners, designate some time on your calendar to do it at least once a week.

Third, you need people and they need you! Even we introverts require some socializing, though we may not want to admit it! Entrepreneurship can be a lonely path. You need others who understand the unique pressures and thrills of being self-employed. It's vital to have a community of people who get you; people who will encourage you to chase your big dreams and pick you up when life knocks you down. And they need you, too! Even if you've only been a business owner for five minutes, you probably have valuable advice and resources to share with other entrepreneurs. A word of warning: make sure that your community is full of positive, success-minded people. The people you spend regular time with have influence over your energy and drive, so choose carefully!

I'm fortunate to have a great team of self-employed creatives in a vast array of businesses (everything from 3-D printing to psychic mediumship) who support me and cheer me on to success, and I do the same for them. So, if you are playing this sport called small business solo, it's time to find a team of like-minded entrepreneurs to get in the game of success with you!

CREATIVE MONEY EXPLORATION
Which like-minded entrepreneurs can you meet with on a regular basis to share resources and support?

CHAPTER 56

Learn More to Earn More

"The more you read, the more things you will know. The more that you learn, the more places you'll go!" ~ Dr. Seuss

D o you want to make more money this year than you did last year? I do! Well, if you want to earn more, you need to learn more. And I'm not talking about going back to college to get your master's degree and accumulating a mound of student loan debt. As the late, great Jim Rohn said, "Formal education will make you a living; self-education will make you a fortune!" The good news is that self-education is available to anyone with a library card, laptop, or cell phone.

If you want your creative business to grow and evolve, you have to grow and evolve. As Mel Robbins, author of *The 5 Second Rule*, says, "Every phase of your business requires a different you." Be sure to allocate money in your business budget for self-education; it's an investment in your future success.

How many books have you read (or listened to) this past year? I typically devour a book a week, and only one in five of them star my favorite cast of vampires, shape shifters, or fairies. I've read or listened to books on the following: how to sell myself and my business, how to deliver more polished presentations, how to manage my money better, how to speak Spanish, and how to improve my health and spiritual life.

Several of these books were so meaty, I felt compelled to go back through them a second or even third time. The two excuses I hear from the self-employed as to why they don't read much are: 1) they struggle with reading, or 2) they don't have time. Fortunately, I have one solution for both issues: audiobooks! Download them right to your phone and listen to them while sitting in traffic, during your workout, or while getting ready in the morning. It's certainly better for your brain and your mood than listening to the news or talk radio. And don't forget the thousands of free and amazing podcasts that are available!

Books aren't the only way to expand your earning power. Depending on your "Continuing Education" budget, you can attend workshops, webinars, classes, conferences, and seminars. What skills do you need to take your earning power to the next level this year for your art and business? This year, I decided to invest in a brand refresh and website overhaul. In the past few years, I've also invested in my speaking skills, networking techniques, and coaching strategies.

And, so, I will ask you again: what skills do you need to take your earning power to the next level this year? Do you need to learn how to speak another language, manage social media, sell your products and services, or better manage your personal finances? Be sure to invest in your education and earmark money in your budget to expand your knowledge and your income!

CREATIVE MONEY EXPLORATION

Commit to increasing your learning in at least one area over the next 30 days. Research books and courses that could fill the need and invest your money in buying one.

CHAPTER 57

Why You Should Pay for a Business Coach

I 'll never pay for advice from a business coach," said a friend and colleague of mine recently. We were having a friendly debate of the merits of utilizing the free advice of mentors and volunteer business organizations versus hiring a business coach. At this point, my friend and I have agreed to disagree; however, I want to share why I believe hiring a business coach is a great investment in your future success. So many creatives are wonderful at their craft but are learning the business side of things as they go. Hiring a business coach is a good way to shorten your learning curve.

Cold, hard cash makes both you and your coach more invested in the success of your business. If I am paying a coach thousands of dollars to work with me, I am going to take the process seriously and they are too. I'm going to do every bit of the homework they assign me, show up to coaching sessions fully prepared, and apply the advice given. If you're getting free advice, it costs you nothing to ignore it. *(Or does it?)*

Coaches see things about your business you don't. Many times, I'm too close to my business to see the big picture; it's the whole "can't see the forest for the trees" analogy. The business coaches I've hired over the years have given me many "a-ha!" moments, which have launched me to the next level of success.

Coaches are experts on income generation and efficiency. They are exposed to a variety of people, businesses, and industries on a regular basis. An effective coach will take ideas, solutions, and processes and see how they transcend a particular business or industry to enrich their clients across the board.

Coaches are accountability partners. As Jim Kruspe, Principal Consultant for Profit Solutions Group says, "Hiring a business coach is essentially paying someone to be your boss." Your coach's job is to make sure you keep the promises you make to yourself about what you're going to accomplish in your business.

A coach is NOT emotional about your art or your business. You are. And so am I. Sometimes I find my initial reaction to a suggestion from my business coach is resistance and defensiveness. I have to step back and ask myself why. The reason is usually that I am married to a particular way of doing things because I'm emotionally attached. Take this book as an example. I was chatting with my friend and writing coach, Christina Young, about this project. I initially intended to target the general entrepreneurial audience. Christina challenged me to focus on a narrower target, a segment of entrepreneurs who needed this advice but felt largely alienated by the finance industry: creative entrepreneurs. My first reaction was resistance to and dismissal of her advice because I'd already started writing the book, thinking it would also be for professionals like attorneys and real estate agents. After thinking about it for a day or two and talking to my self-employed creative friends, I realized her advice was pure genius. A coach's job is to make you and your business better and more profitable, which usually requires change and the setting aside of your ego.

I'm not saying that you shouldn't utilize mentors or other sources of free business advice, especially when your business is young and money is tight. However, in my experience, putting down cold, hard cash to hire a business coach, especially if it scares you, is going to motivate you to bring your A-game and produce a good ROI from your coaching dollars.

CREATIVE MONEY EXPLORATION

Is it time to hire a coach to take your business to the next level? Who would your dream mentor, coach, or guru be? Investigate how much the investment would be to work with him or her.

CHAPTER 58

Selecting the Right Coach for You

Are you convinced hiring a business coach is the right move to help you grow your creative business? If so, how do you select the right one for you to get the most bang for your buck? Business coaches abound, and there are certainly some bad apples out there.

Here are some guidelines to follow when interviewing and selecting the right coach for you.

Identify exactly the kind of help you need from your business coach. Is it increasing your income? Do you need clarity around your brand and marketing activities? Although some business coaches are similar to your general practitioner doctor, most are specialists. Over the past few years, I've worked with a variety of coaches on different areas of my business. I hired a success coach to teach me how to network effectively and build solid referral partner relationships. I hired a speaking coach to show me how to refine my presentation skills and material, as well as teach me the business of keynote speaking. I hired a coach to help me hone my blogging skills and Google optimize my website. I hired yet another business coach to teach me how to create amazing online programs and successfully run a membership group. Ensure the coach you select is a specialist in the area of your business which needs the most attention.

Get references from the coaches you're considering and CALL them! Look, you're going to plunk down your hard-

earned cash to work with this person, so invest a little time to check their references. (And if they can't provide you with any, move on.) I'm shocked by how many people skip this step. Ask the references about their general experience with the coach, what they liked best and least about the coaching process, and their return on investment from the coaching they received. Have their past coaching clients achieved the level of results you're after?

While you're at it, check their credentials. Visit their website, read the testimonials, and check their credentials. Your business coach should have received some type of education or formal training. If a coach is a part of a franchise, this is typically required to remain affiliated with the parent company. Anyone can tack the word "coach" onto their job description, but formal training separates the amateurs from the professionals.

Ask how you'll be working together and how much personal support you'll receive with your coaching package. Most professional coaches will send you a coaching agreement or guidelines, spelling out the details. How will coaching sessions be conducted: by phone, in person, or via video chat? How long is each appointment? Will you have phone, email, or private message access to your coach in between sessions if you have questions? It's important to set expectations up front so you know exactly what to expect from your coach and what he or she can expect from you in return (doing your assignments, showing up to coaching sessions on time, etc.).

Do a gut check. Finally, ask yourself if you feel excited about working with this person. You're going to spend considerable time talking and interacting with your coach. It's important to feel comfortable being vulnerable about your business struggles so they can give you the assistance you need. The ideal coach will be able to give you the advice and constructive criticism you require without crushing your enthusiasm.

The old HR hiring adage applies to business coaches as well as employees: "Hire slow and fire fast." Do your homework and make an educated decision when selecting a business coach. Ask about their refund policy if you decide after a few weeks that

you've hired the wrong person for the job. Most coaches worth their salt will offer a refund or release you from your coaching contract early if you're not satisfied. (By the way, these guidelines work well for hiring personal coaches—life coaches, financial coaches, fitness coaches, too.)

CREATIVE MONEY EXPLORATION

Which area of your business is in glaring need of improvement? Ask around for referrals for coaches with that specialty and interview two or three of them before making a hiring decision.

CHAPTER 59

Blast Through Fear & Procrastination

I t's barely the crack of dawn and you're just making a dent in your first cup of coffee. You check your phone and see the networking event that starts at 8 AM. You know you should go because there will likely be people in attendance who would be great business connections for you. Then it kicks in: the excuses, the procrastination, and the feeling of discomfort about walking into a room where you probably won't know anyone.

As a creative entrepreneur, you don't have anyone looking over your shoulder who's going to make you go to the networking event (or pick up the phone to call the potential customer or talk to the scary successful person and ask them to be your mentor). If you allow fear and procrastination to win, it will cost you in real dollars in your business.

Here's How to Blast Through Fear and Procrastination.

Become aware of your triggers. What are the situations in your business or life where you tend to procrastinate or avoid out of fear or anxiety? It could be networking, making sales calls, crunching the numbers, dealing with toxic vendors, or even driving in downtown traffic. A sure-fire way to identify these triggers is the nagging feeling of resistance when you think about them.

Examine WHY this situation triggers your avoidance. Last year you went to a networking event, forcing yourself outside of your comfort zone. You attempted to engage someone you looked up to in your industry and they snubbed you. Every time you think about attending any networking event, the memory surfaces and you envision it happening again. Most of the time, the thing we fear rarely happens. But occasionally it does. It's part of life and business; try not to take it personally when someone tells you no or things don't work out as planned.

Level up your skills. Perhaps you become tongue-tied when making sales calls and don't know what to say in response to objections. Maybe you need to level up your sales or interpersonal skills. If your fear or procrastination around a business activity is due to a lack of skill or knowledge, taking a class or hiring a coach will give you confidence and mastery. Most business owners, me included, are not born networkers, public speakers, or sales people. I had to invest the time and money to learn these skills via coaches, classes, books, and webinars.

5, 4, 3, 2, 1, Go! Once you're aware of your fear and procrastination triggers, it's time to blast right through them. You can use this tool, created by author and speaker, Mel Robbins, even while you are exploring your triggers and leveling up your skills. It's called, "The 5 Second Rule"; here's how it works. When you feel the urge to do something positive and proactive for your business (or any area of your life), before the resistance kicks in, count down in your head, "5, 4, 3, 2, 1, Go!" and physically move. This short-circuits the fear and procrastination so you can take action. I highly recommend listening or reading Mel Robbins' book, *The 5 Second Rule*. In it, she explains the science behind why the countdown works and the many ways it can be applied to increase your confidence and productivity.

Look, if you are going to be a financially successful entrepreneur or business owner, you're going to have to do things that push you out of your comfort zone on a consistent basis. Use these tools to identify and blast through fear and procrastination so you can take your business to new heights.

Here's an example of how this played out in my own life. I attended a committee meeting at the chamber of commerce, and someone passed around a flier for a women's event being held in downtown Cincinnati the following week. I looked at the flier and did a double-take. The speaker being featured at this event was a bestselling author whose book has been a huge positive influence on me.

I wanted to go but felt resistance because: 1) I had a conflicting appointment, 2) the event was in the city, and I always stress out when I have to drive downtown. What if I can't find anywhere to park? What if I get lost and end up in a bad part of town? 3) What if I actually get to talk to my idol author? What should I say? Will I get completely tongue-tied and say something stupid?

If you're wondering, yes, I did make it to the women's event where *Mel Robbins* was speaking. Yes, I talked to her and gave her a copy of my book. She surprised me by insisting we get a selfie together! In a word, it was awesome! And I can't believe I almost didn't go. But I used the 5 Second Rule to push past my resistance and I did.

As Barbara (Stanny) Huson, author of *Sacred Success: A Course in Financial Miracles*, says, "Fear is the clearest signal we'll receive that we're on the precipice of greater success, greater prosperity, greater happiness, greater impact. Imagine if every time we got scared, instead of freaking out, we gave each other a big high-five and exclaimed: 'YES! Greatness, here we come!'"

CREATIVE MONEY EXPLORATION

If inaction due to fear or procrastination is an issue for you, follow the steps in this chapter and grab a copy of *The 5 Second Rule* by Mel Robbins.

CHAPTER 60

The Evolution of Your Creative Business

Your creative business is a living, growing, breathing thing. If your business *isn't* growing, changing, and evolving, then it's stagnating and dying. When we start our businesses, we envision how our business will evolve over time. But things rarely happen precisely as we imagine they will. Rather than rigidly clinging to the exact details of your vision, I encourage you to be open to new ideas and directions as your creative business grows.

Ashley Peacock, music producer and owner of Soul Foundry, encourages the musicians he works with to reconcile with failure. "Failure is education in disguise. Your plans and projects won't always work out exactly as you planned. Learn from failure and build on it, rather than letting it destroy you."

Because I am a raving fan of cultivating a positive mindset in both business and life, I'm sold on the power of our thoughts and manifesting our desires. In *Playing the Matrix*, author Mike Dooley explains where many of us get lost in what he calls the "Bermuda Triangle of Manifesting." He says that when we become too fixated on the details (the how) of our desired manifestations, we may exclude other, even better, outcomes.

If we become obsessed with our success coming to us via a particular person, in a particular way (ex: a product or service

we sell), or by a strict deadline, we may very well be disappointed. Dooley explains how we should be focused on the general outcome (personal happiness and financial success in our business), but not become overly attached to the details of *how* it will happen. If we do this, we will be open to delightful and surprising sources of income for our creative businesses.

Just as we should be open to new ventures, collaborations, and offerings within our business, we must also be willing to release what is no longer serving us. Products, services, partnerships, and activities which are no longer profitable or which deplete us may need to go.

Here are a few things to consider regarding the evolution of your creative business:

As new ideas are presented to you, consider how they will further the core mission of your business. For example, my mission is to empower as many people as possible to rescue their financial dignity, both personally and professionally. When I consider writing a new book, launching a new online course, or collaborating with others on a project, it must support my core mission of guiding people towards financial dignity.

As you consider your current business activities, products, services, and joint ventures, are there any that leave you feeling drained emotionally or financially? Why are you clinging to them? Maybe it's time to release them so you have the time and energy available to allow something better to fill its place.

Are changes in technology opening up emerging possibilities in your creative business? As technology evolves, it not only has the capacity to bring you new opportunities but also to make some of your offerings obsolete. It's important to be aware of the influences tech has on your art and your target market. I'm not a techie and that's why I surround myself with a team of advisors who are smarter than me in this area. When I was revamping my website to freshen the look and automate the sale of my online offerings, I felt like a fish out of water trying to evaluate what tools I need to accomplish it. I knew this technology would further my mission to reach more people, so I needed to embrace my discomfort and move forward with the assistance of my tech-savvy gurus.

Are the needs and wants of your target market in flux? Sometimes there are changes in the economy, world events, or politics that alter the needs and wants of your ideal customers. How can you better serve people in light of these changes? For example, during the recession, an interior decorator I know morphed her business to focus on bringing a luxurious look to her clients' homes with a strict budget in mind. She does this by finding less expensive, but great-look alternatives to custom cabinets, tin-punched ceilings, and granite counter tops.

Be open to what the future may bring in your business! Cling to your mission and the big picture results you want, but don't get married to the details of how it will happen. And keep in mind that success is not all or nothing! "Some musicians think there are only two options for them: a starving artist living in a studio apartment eating ramen noodles or a famous millionaire taking champagne bubble baths in music videos," says Peacock. The fact is that most creatives live between the two extremes. You don't have to live in a mansion or be nationally known to make a good living and a good life as a creative entrepreneur.

CREATIVE MONEY EXPLORATION

Are there new ventures, collaborations, or offerings you should entertain in your creative business? If so, what are they? Do they fit into your overall mission and vision for your business?

What products, services, partnerships, or activities might you need to release because they're no longer profitable or enjoyable for you?

CHAPTER 61

When to Throw In the Towel

"**N**ever give up!" We see this slogan plastered on mugs, t-shirts, and memes all over the internet. But is it ever okay to give up on a product or service line, even your whole business? When should you throw in the towel, and when should you double down? If your business is floundering and isn't providing you with a livable income, *should* you throw in the towel?

If your business is draining your personal savings or retirement accounts, a red flag should go up. If you are racking up personal debt to keep the business afloat, a seriously huge red flag should go up. It's hard to release a beloved product line or business because we're emotionally attached to it. The thought of closing or selling a business feels like putting your child up for adoption. But clinging to a sinking ship for too long to preserve our egos may cause our financial health to flat-line.

The first thing you must do is seek outside help. Although you may think you can't afford to pay a business coach, CPA, accountant, or money coach, it's vitally important for you to get a fresh set of eyes on the situation. This person will dig into the details and uncover problem areas. You'll receive an unbiased opinion of the long-term viability of your business, plus concrete suggestions for rectifying the situation. You may find that, with a few adjustments, your business can be saved.

The majority of successful business owners have several defunct ideas, products, and ventures in their past. Don't view it as failure, but rather a learning experience. Just because one business venture doesn't pan out, this doesn't disqualify you from being a creative entrepreneur. Most people don't know this, but I have a failed partnership venture in my past.

When I first became self-employed, I wasn't just a money coach, I was also a coupon queen. In addition to my coaching company, I had a partnership with a software engineer who created a program to track coupons and a family's food inventory. It was called, "The Coupon Wizard," and we planned to sell this program to families all over the United States who wanted to cut their food expenses through couponing and meal planning. Because we were still in a recession, the idea seemed like my golden ticket to success. Since I'm sure this is the first time you've heard of The Coupon Wizard, you can safely surmise this business didn't produce results. We shut down the partnership after only two years. Honestly, I was a little disappointed, but I didn't beat myself over the failed venture. Instead, I threw myself into growing my Financial Lifeguard brand and the coaching business.

There is no shame in exiting the entrepreneurial world to go to work for someone else if that makes sense for you. If you find a creative job you enjoy with a solid company and are well compensated for it, go for it! You're not somehow "less than" because you decided being self-employed wasn't in your best interest. If your business is draining you and stressing you out, this may be the right move for your financial and mental health. A failing business can put tremendous strain on a family, so don't allow your venture to ruin your personal life.

And just because you set aside the title of self-employed, it doesn't mean you can't pick it back up in the future. I've talked with self-employed creatives who took a break from entrepreneurship for a period of time, so they could get their personal finances in order and be in a better position to relaunch their businesses at a future date.

Ironically, I personally wrestled with this while writing this book. In all honesty, I thought, "Who am I to be writing this

book for creative entrepreneurs when I'm having my worst year financially in my own business?!" It was discouraging to say the least. I didn't need to hire a business coach to know what caused the situation.

In 2017, I invested several thousand dollars of my own money into publishing my first book, *Money is Emotional*. I'm not the type of person to half-ass anything, and I wanted my book to have the look and feel of a New York Times Bestseller. Mission accomplished! I am super proud of the book in all its formats because it is professional and polished. I don't regret investing the money into that project, because I am certain it will generate income for me for years to come.

In addition to having extra expenses for the publication and marketing of my book, I also decided to give up my one bookkeeping client, my family's business. This job occupied 25% of my monthly productive time, and it wasn't what I wanted to be doing. Yes, I can do accounting work well even half-asleep, but it doesn't energize me. I wanted to reclaim that time for coaching entrepreneurs and teaching corporate money wellness classes. When you turn a cash flow funnel off, the ones meant to replace it don't usually start gushing money immediately. The ramp-up time for the replacement funnels took longer than I anticipated.

I have to be honest with you: I thought about throwing in the towel. For the first time in five years, there wasn't enough cash to pay myself out of the business. I pulled from my personal savings to pay bills and the shrinking balance stressed me out. I considered going back to a full-time accounting position, or maybe applying to be a corporate wellness specialist. I thought about keeping the business and getting a side hustle.

I edited three books for other authors and wrote copy for websites and marketing materials. I thought I could rekindle the editing side hustle while continuing the Financial Lifeguard business. I talked with my husband, fellow trusted referral partners, and mentors. I cried more times than I'd like to admit. Then I did something that even I thought was crazy. I forked over money out of my dwindling savings account to work with

a kick-ass business coach and a web designer. I decided to double down.

There was a rough period of months where I felt like I was teetering on the edge of destruction, which made me feel stressed and depressed. But here's the fabulous news: the investment in my coaching and rebranding is paying off big-time. I'm back to paying myself regularly out of the business and rebuilding my savings balance. My confidence in myself and my business has skyrocketed, thanks to the skills I've acquired and my amazing website and branding. New opportunities are flowing my way on a regular basis.

But here's the thing: if my business hadn't turned around, I would have rekindled my side hustle or taken a part-time job. I wouldn't have beat myself up over it because I'm not willing to risk my family's financial health for the sake of my pride. And either way, I definitely would have finished this book for you.

CREATIVE MONEY EXPLORATION

Are you considering throwing in the towel on a particular service or product line within your business? Or maybe on your entire business? If so, why? Talk with a business coach, or someone else you trust, before making a decision.

CHAPTER 62

Take Care of Your Best Employee: You!

The greatest asset in your creative business is *you*. You are the goose that lays the golden eggs. If you don't nurture yourself physically, mentally, emotionally, and relationally, you won't have sustainable creative production. If you work yourself half to death, you'll resemble a "battery hen," a commercial egg-laying chicken kept in a small cage with one-third of the lifespan of a barnyard hen.

Think of yourself like that hen. If you try to squeeze every last ounce of creative production from yourself with no breaks, you'll end up like that poor battery hen: frazzled, exhausted, and prematurely worn out. And unlike a commercially raised chicken, you have the ability to release yourself from the cage of over-work whenever you choose. Allow yourself sunshine, exercise, and social time so your creative "eggs" will be of the highest quality.

There are several areas of self-care that are vitally important for an entrepreneurial creative to thrive long term. You need to feed your mind and your creativity. You need to nurture yourself physically. You need to spend time with friends and family. And you need periods of rest from your work.

It's important to work on your mindset regularly via journaling, affirmations, and meditation. This is something I do

daily. I know my mindset is either my secret weapon for success or my Achilles heel. Spend just a few minutes in the morning every day to ensure your head is in the game. Feed your intellect via books, classes, and audio programs both for business and pleasure. I'm always in the middle of at least four or five books and I make sure one is purely for pleasure.

Because you're depleting your creative reserves for your business, it's important you replenish them on a regular basis. Attend art exhibits, concerts, and theatrical performances. I'm always amazed how these creative outings inspire me in my own work, even if the two seem completely unrelated. If your inner artist is starving for inspiration, you're not going to show up well in your business.

Our physical wellbeing affects our creative production and our state of mind. Exercise releases endorphins, which are nature's happy pills. Make physical exercise fun and playful rather than picking a torturous activity that you think you "should" do for exercise. Personally, I do not enjoy running, so I avoid it. But I love yoga, kick boxing, swimming, roller skating, and walking outside in nature. Find a physical activity that appeals to you and commit to doing it at least three or four times a week. While you're at it, feed your body healthy and nutritious foods at least 80-90% of the time.

Carve out quality time to spend with your family and friends, preferably positive, high-vibe people. Social ties are important to your well-being. Involve friends and family in your creative outings or your fun exercise sessions.

Create periods of rest from your work daily, weekly, monthly, and annually. We discussed this in the time management session but it bears repeating here. Have set stopping points for your daily work so you're not neglecting your family. Unplug from work at least one day per week and one weekend per month. And for God's sake, please take a vacation at least once a year! Entrepreneurs take less vacation time than those who are traditionally employed, but it is doable with advanced planning. The bonus is that when you return to work from these breaks you'll be refreshed and more productive.

If your business is profitable but you're stressed out and sleep deprived, you may be on the fast-track to burnout. What do you need to do to take care of your best employee (you) right now?

CREATIVE MONEY EXPLORATION

When was the last time you took your inner artist on a "play date?" Write down 5 creative outings that sound fun. Put one on your calendar for the next week.

What physical activities seem more like play than exercise? Dancing, rock climbing, hiking with your dog, skiing, etc. Write down at least three. Put one on the calendar for this week.

Who in your family or circle of friends should accompany you in either your creative outing or sweat session? Invite that person to join you.

CHAPTER 63

Coming Full Circle

Now it's time to get back to the Creative Money Exploration from Chapter Five, Unmasking Money Drama, where you created something in your artistic wheelhouse that conveyed how you felt about money. This is your "before" so now it's time to revise it into the "after." Revamp your poem, short story, song, one-act play, or letter to money so it represents what your improved relationship with money looks like.

As you might remember, I wrote a letter to money. Here's the "before" version:

Dear Money,

I feel like you are playing hard to get. When I do everything I know to make you, you barely trickle in. Sometimes, I'll ignore you and you show up in unexpected ways. It's just enough to keep me chasing after you. I'm afraid that if I don't have enough of you, my husband, Nick, will be resentful that I'm not contributing my fair share to the household expenses. I don't want to be a financial burden on him or anyone else.

I'm scared now that I have given up KRC (my family's business) as a source of revenue that I'll have to take a part-time job working for someone else to make up for it. I'd much rather earn my money empowering people to rescue their financial dignity through my coaching, courses, and books. This is the

first time in my life that I don't have a reliable, steady source of you, which really freaks me out. I dislike not knowing where the income's going to come from every month. I'm really tired of chasing you, Money. I really wish that you'd commit to being with me all the time. Please, please, please don't leave me!!

~ Christine

And here is my "after" version:

Dear Money,

Ever since I decided to stop trying to control you and instead improve our relationship, we've both been so much happier! I'm no longer worried that you'll leave me and never come back. Because I'm showing you respect and spending regular quality time with you, you're eager to hang out with me. I now understand that when you come flowing into my life, Money, you want me to joyfully save, spend, and give you away without fear.

Like the ocean tide that ebbs and flows consistently, you have a natural rhythm of flowing into and out of my hands. Rather than trying to keep you all to myself out of fear, I'm learning to relax into this rhythm of ebbing and flowing. By doing this, I'm finding you're flowing my way more frequently and in larger amounts than I anticipated. I'm spending you on things that are important to me and adding value to my life (like beach vacations!). I'm giving you generously to charities and causes close to my heart, which fills me with gratitude and joy. Now that I've learned to have an amazing relationship with you, Money, I'm excited about our future and how we will positively impact the world!

With Love,
Christine

CREATIVE MONEY EXPLORATION

Create your artistic expression of your "after," something that represents you and money having an amazing relationship! Bonus points: Use hashtag #CreativeMoneyExploration to post on social media and tag me.

CHAPTER 64

Go Get 'Em, Boss!

Congratulations! You finished the book. Way to stick with it! Now that you've mastered the basics of business and money, make them an extension of your art. How you meld your business and your art together is a creative process unto itself. The final masterpiece is up to you.

Remember, you and money can change the world. So, go get 'em, Boss!

THE COLLECTIVE

Now that you've finished the book, consider joining me in the *Manage Money Like a Boss Collective*. This membership group is for creative entrepreneurs who crave on-going support, education, and accountability in their small businesses.

There are monthly live video trainings from your Financial Lifeguard (me!) plus special guest experts to help you with every aspect of your business that impacts your bottom line. For more information and to join *The Collective*, go to: www.ManageMoneyLikeABoss.com

ALSO BY CHRISTINE LUKEN

Money is Emotional:
Prevent Your Heart From Hijacking Your Wallet

If money is emotional, then why do we persist in trying to manage our personal finances logically? We already know what it takes to become financially healthy: spend less than we make, pay down our debt, and save more money. Money management books, tools, and techniques abound, yet most of us don't utilize them. Maybe you've adopted the practice of ignoring money problems until they are barreling down on you like a tidal wave, as I once did. *I know what it feels like to be drowning financially.*

I'd like to propose a better alternative, one that doesn't require you to eat beans and rice or to spend hours updating budget spreadsheets. My approach to personal finance is called "Mindful Money Management." It is unique in that it harnesses the power of your emotions, so they can propel you forward like a rocket booster towards your Preferred Financial Destination. Yes, money is emotional, but you can prevent your heart from hijacking your wallet. This book will show you how. Download the first three chapters at www.MoneyIsEmotional.com

Recommended Resources

Books:

Money is Emotional: Prevent Your Heart from Hijacking Your Wallet by Christine Luken (Mastering your personal finances)

The 5 Second Rule by Mel Robbins (Overcoming fear and procrastination)

Your First Six Figures: Eight Keys to Unlocking Freedom, Flow, and Financial Success with Your Online Business by Jen Scalia (Creating a successful online based business)

You Are a Badass at Making Money by Jen Sincero (Creating a solid money mindset)

Quitter: Closing the Gap Between Your Day Job & Your Dream Job by Jon Acuff (Using your day job as a launch pad to start your own business)

The Hollywood Commandments: A Spiritual Guide to Secular Success by DeVon Franklin (Spirituality and business don't have to be at odds with each other)

Rockin' Your Business Finances by Christine Odle (Workbook to baby step you through your accounting numbers)

Saying No to Friends Who Want You to Work for Free (Jon Acuff's blog post) https://acuff.me/2016/09/say-no-friends-want-work-free/

The Artist's Way by Julia Cameron (Nurturing your creativity for long term productivity)

Avoiding the Networking Disconnect by Brennan Scanlon and Ivan Misner (How to effectively build your network)

If You're Not First, You're Last by Grant Cardone (Sales strategies)

What Every Body is Saying: An Ex-FBI Agent's Guide to Speed Reading People by Joe Navarro (Body language)

Playing the Matrix by Mike Dooley (Manifesting the right way)

Worthy: Boost Your Self-Worth to Grow Your Net Worth by Nancy Levin (Connection between self-worth and finances)

Sacred Success: A Course in Financial Miracles by Barbara (Stanny) Huson (Growing your money while creating a deeper, richer, and more meaningful life)

COACHES:
Christine Luken, Financial Coach
Website: www.ChristineLuken.com

Nanette Polito, Success Coach
Website: nanettepolito.com

Jenn Scalia, Mindset & Online Visibility Coach
Website: jennscalia.com

Betsy Kent, Digital Content & Marketing Coach
Website: bevisible.co

Kyla Woods, Communications & Media Coach
Website: crowdorcamera.com

Fabi Paolini, Web Designer & Branding Coach
Website: www.fabipaolini.com

TOOLS:

Pipedrive (Online tool to manage your sales leads)

QuickBooks (Online accounting software)

TimeTrade (Online appointment scheduler)

Buffer (Social media scheduler)

HARO®www.Helpareporter.com (Become a source for reporters)

Zoom (Video Chat, Meeting and Webinar Platform)